IMAGES
of America

EMIGRANT GULCH
SEARCHING FOR GOLD IN
PARK COUNTY, MONTANA

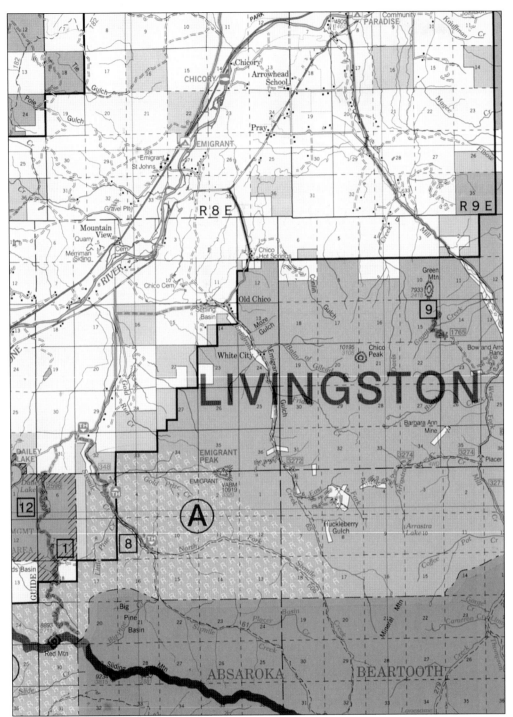

This portion of the Gallatin National Forest, East Half, shows just the part dealt with in this book of Emigrant Gulch. The whole map can be bought at the Forest Service office in either Gardiner or Livingston for $4.

IMAGES
of America

EMIGRANT GULCH
SEARCHING FOR GOLD IN PARK COUNTY, MONTANA

Doris Whithorn

ARCADIA
PUBLISHING

ISBN 978-0-7385-2078-0

Published by Arcadia Publishing
Charleston SC, Chicago IL, Portsmouth NH, San Francisco CA

Printed in the United States of America

Library of Congress Catalog Card Number: 2002110147

For all general information contact Arcadia Publishing at:
Telephone 843-853-2070
Fax 843-853-0044
E-Mail sales@arcadiapublishing.com
For customer service and orders:
Toll-Free 1-888-313-2665

Visit us on the Internet at www.arcadiapublishing.com

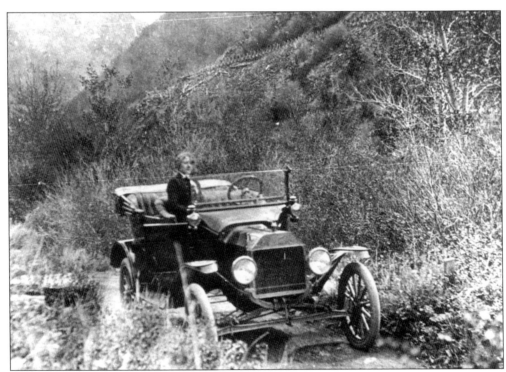

Pictured is Emigrant Gulch in early times. Carl and Esther Wilcoxson made a trip up Emigrant Gulch in their 1914 Ford and stopped for a picture on a road that we would think poorly suited for travel. Above on the hillside can be seen a flume, which would indicate that miners were at work in the area.

CONTENTS

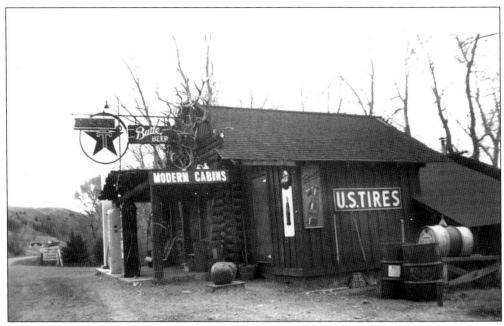

The Wan-I-Gan, October 1948. Like Topsy, The Wan-I-Gan "grew."

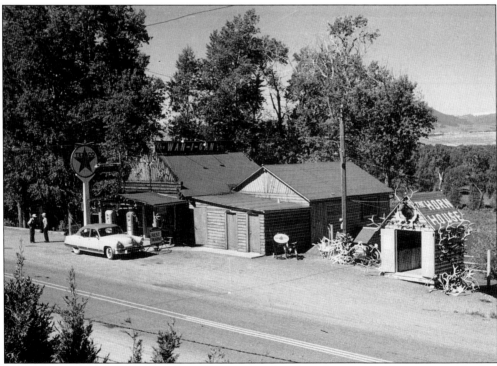

The Wan-I-Gan, 1955. In 1960 we added a cage of rattlesnakes as a local attraction. Neither free antler key chains nor free spring water stopped patrons as did that cage of rattlesnakes.

INTRODUCTION

When our family took over The Wan-I-Gan in October of 1948, there was a postal card among the stock that showed a Gold Dredge with Emigrant Peak in the background. That was the first indication to us that there was "gold in them thar hills" that we were moving near. We were as ignorant of the area surrounding the 17 acres we were buying on the banks of the Yellowstone River as we were of how to run a business or how far it would be for our children to attend school. We learned that the neighbors were feeling sorry for "that family." All that my husband wanted was to leave the nerve-racking duties of the newspapers where he had worked for 10 years. I went along with his wish.

Thus we arrived with a truck load of "stuff," a car full of kids, and a debt that the locals considered insurmountable for us. We had come to answer an ad over the Labor Day holiday when business was rushing. How could we have guessed that at any other time of the year, it might be painfully slow? But, we learned!

The Wan-I-Gan was in the middle of Paradise Valley, as pretty an area as anyone could imagine. There were high mountains on each side. To add to the beauty, they were lightly covered with snow.

Bruce, our oldest, had attended a month of school in Billings. Carol was five years old. The teacher (knowing how burdened I would be with two younger children—one not yet walking) suggested that perhaps she would be allowed to enroll Carol in school, too. The County superintendent waived the six year old requirement, and Carol started, too—six weeks late at a school five miles from home. The teacher went past our door and furnished transportation—a real boon.

A month into living with the small store in front of a kitchen-living room combination with two bedrooms down stairs, 150 feet above the Yellowstone River, I was asked if I wanted some boarders. They would be installing electricity in Tom Miner Basin, 15 miles up the road. We had 12 cabins for rent, and I took the crew. Their room and board gave us a little income at a crucial time. Then in early December a busy elk hunting season on "the Firing Line" 30 miles up the valley opened. Again we thrived for a time. The hunting season closed January 4 and again business was slow.

Somehow we survived that first year and we began to feel at home in our new enterprise. We managed to pay the bills. I got to hire some occasional help which allowed me a bit of freedom. The gold dredge of the postcard had been moved to South America just before we came to The Wan-I-Gan. Few people were looking for gold in "them thar hills"—but we gained an interest in activities around. We joined a few clubs and attended church.

When ten years had passed and we had paid off our debt, we hosted a big community-wide mortgage-burning party and corn roast. Things were looking better. We had enlarged our living quarters. A local doctor sent many patients to stay in our cabins. I even helped him with baby deliveries and sometimes minor operations. We found time to investigate our surroundings. Emigrant Gulch became an area of fascination.

By that time Bill was making photography a hobby. He reproduced pictures for neighbors that wanted copies. He worked summers in Yellowstone Park as a maintenance man, and he could always be called on for maintenance at home, too. We had picnics up in Emigrant Gulch. I read old newspapers at the Livingston Library and kept notes on where I read what. I was given more freedom by a local rancher's wife, Benna Busby. She worked for me for 17 years. Some

people thought she was the boss, and she was when I was gone. There was activity in Emigrant Gulch and many of the workmen stayed at The Wan-I-Gan. It was an interesting time. We had a chance to travel. We hit all 50 states and made several trips to Europe. The best of those was when Carol was teaching in Germany for the Department of Defense.

We sold The Wan-I-Gan in 1976 and moved to Livingston, where we set up the Park County Museum (now the Yellowstone Gateway Museum) with much volunteer help. We were there 10 years. Bill continued his photographic work there and later in a private home. But I lost my chief picture-producer in 1990. We had 51 years together. I was left with pictures galore—negatives, slides, color prints, projectors, you name it!

By 2002 I had a whole cupboard full of Emigrant Gulch. I have sorted little slips of paper, long carbon-copied stories, and photos trying to put them into categories, but often they overlap. Eight years ago I made a video of Emigrant's history. I enjoy showing it, and I made copies of it. But when I get down to those little slips of paper that give me a reference, how can I abbreviate it to be of interest to a reader?

All I can say is, "I tried."

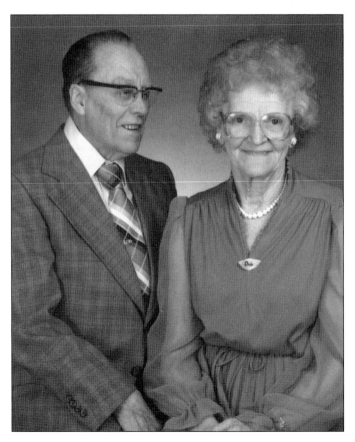

This was our 50th Anniversary photo. Bill always wanted the right side of his face to show. His left eye had been an artificial one since he was 12 years old.

One

WESTWARD HO!

Ith genealogy the second most popular hobby (after stamp collecting) in the world, the
descendants of John J. and Margaret Tomlinson had a real treasure in the diaries written
almost daily as they traveled from Iowa to the gold fields of Montana. Tomlinson had an odom-
eter on his wagon and shared with fellow travelers the distance covered each day.

They told of waiting at Richard's Bridge (east of Casper) for a total of 68 wagons to be making
the trip over the newly opened Bozeman Trail through country with good grass and water, but
with hostile Indians. He told of the Townsend Train which had pulled out on that trail shortly
before they had. They had come upon a scalp of one of its members hanging on a tree with blood
still dripping from it.

Fishing was good along the route and game was plentiful. When wood was scarce, buffalo
chips were adequate for fires. He told of seeing the first jack rabbit and of the herds of buffalo.
At one time he said a buffalo ran through their camp and 40 unsuccessful shots were fired.

Tomlinson told of dogs splitting the train. Another diarist said one dog stampeded the cattle
and four horns were knocked off. A wagon axle broke. Both mentioned the hot springs, now
known as Hunter's. Finally, the "wayward brothers" were met and the problems solved.

This is the
map which
George Strick-
land drew in
1975 to go with
the Tomlinsons'
diaries.

John Tom-
linson was
born near Fort
Cumberland,
Maryland in 1812. He studied surveying and civil
engineering. With his father he farmed and oper-
ated mills. At 20 he built one of his own. He worked
at milling as he moved westward through Ohio,
Indiana, and Michigan. In the 1840s he had a flour
mill and woolen mill in Canton, Iowa. Fires and bad
debts made him decide to go farther west in 1864.
He brought with him to Emigrant Gulch the parts of
a lumber mill.

Oregon trail markers were placed along the route
by the state of Nebraska in 1912. Oregon became
the 33rd state in 1859.

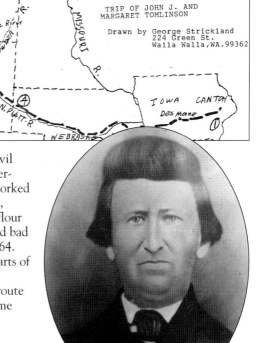

Both Tomlinsons wrote in their diaries about seeing
Chimney Rock in the distance in southern Nebraska
as they traveled west.

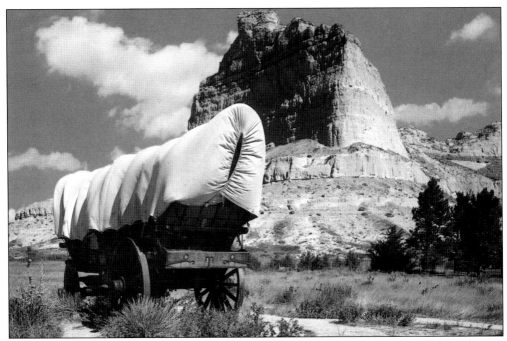

This Conestoga wagon near Eagle Rock in the Scotts Bluff area was the type used to haul goods from Missouri westward. They operated through the last half of the 19th century. Trains of freight wagons followed the same route west as families did in their lighter, less expensive wagons.

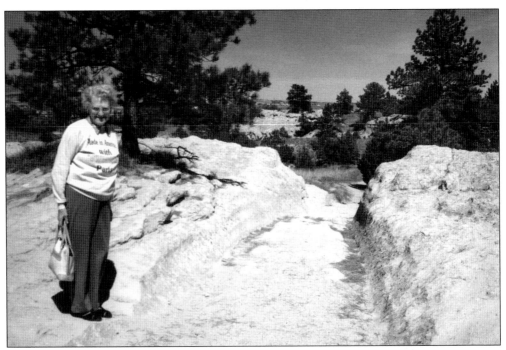

Ruts made by the many travelers along the Oregon Trail are very visible west of Guernsey, Wyoming. They are visited by many tourists every year as I did here in May 1998.

The 1885 *History of Montana* says that John M. Bozeman led 40 wagons over a trail along the base of Big Horn Mountains in Wyoming and arrived with it in the Gallatin Valley on August 1, 1864. As far as I can learn he never actually led another group himself. Those who chose to go the Bozeman route left Richard's Bridge on July 12 with 68 wagons on the trail.

Jim Bridger, noted explorer who had been in Emigrant Gulch before, took 36 of the wagon trains from Pennsylvania and Iowa to Waltman Crossing before heading north to Montana gold fields. He went up through the Wind River country and entered the Yellowstone about ten miles east of Big Timber. His part of the train was referred to as Stafford's.

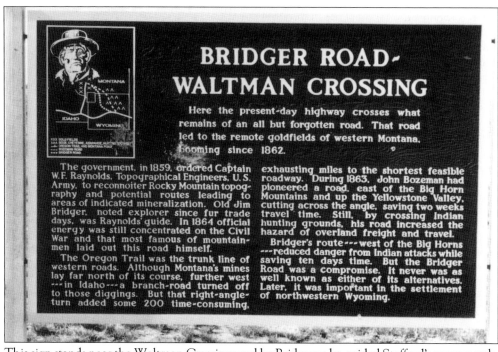

BRIDGER ROAD-
WALTMAN CROSSING

Here the present-day highway crosses what remains of an all but forgotten road. That road led to the remote goldfields of western Montana, booming since 1862.

The government, in 1859, ordered Captain W.F. Raynolds, Topographical Engineers, U.S. Army, to reconnoiter Rocky Mountain topography and potential routes leading to areas of indicated mineralization. Old Jim Bridger, noted explorer since fur trade days, was Raynolds' guide. In 1864 official energy was still concentrated on the Civil War and that most famous of mountainmen laid out this road himself.

The Oregon Trail was the trunk line of western roads. Although Montana's mines lay far north of its course, further west ---in Idaho---a branch-road turned off to those diggings. But that right-angle-turn added some 200 time-consuming,

exhausting miles to the shortest feasible roadway. During 1863, John Bozeman had pioneered a road, east of the Big Horn Mountains and up the Yellowstone Valley, cutting across the angle, saving two weeks travel time. Still, by crossing Indian hunting grounds, his road increased the hazard of overland freight and travel.

Bridger's route ---west of the Big Horns ---reduced danger from Indian attacks while saving ten days time. But the Bridger Road was a compromise. It never was as well known as either of its alternatives. Later, it was important in the settlement of northwestern Wyoming.

This sign stands near the Waltman Crossing used by Bridger as he guided Stafford's group north. Bob Skillman says that some trees on the south side of the Yellowstone in Park County show rope burns that were made when ropes around the trees eased the wagons down cliffs.

Those who came to the fourth canyon of the Yellowstone by way of Bozeman's route found the canyon impassable. They found that by entering a ravine below the canyon and going west about a mile, they could rope their wagons to trees and ease them down. The rope burns still show on four trees at Bullis Creek. One is shown here next to Lindsay Orr's elbow.

12

David R. Shorthill was one of the Pennsylvanians who followed the Bozeman Trail. He had been severely wounded in the Civil War at Antietam and discharged. Having had experience mining in Colorado, he went farther up the Gulch than had Curry's men and discovered valuable claims. He eventually brought his family to the valley to make their home.

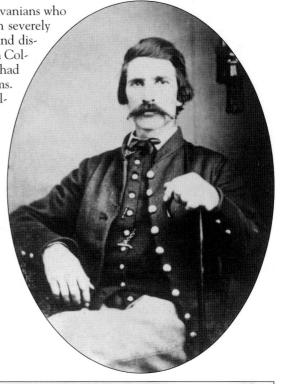

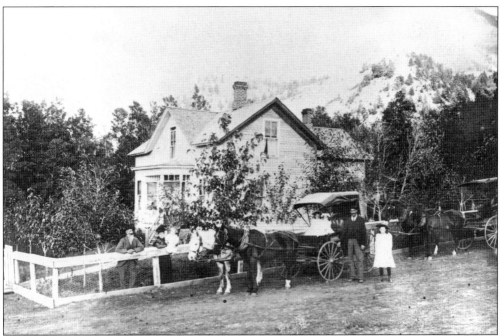

Shorthill took his family of six girls and two sons to Texas and Colorado before returning to ranch in the Yellowstone Valley. Here he is shown by the fence with his daughter Mrs. Joe George and baby Raymond. Joe George and Edith are near the buggy. Mae and Vera are in the buggy. Mr. Shorthill planted these trees.

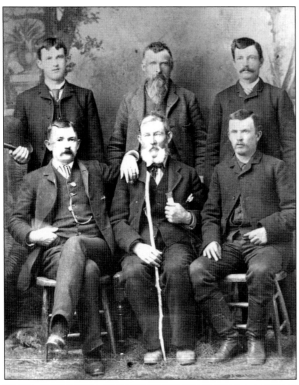

Cycrus Coffenbury was elected major of those on the Bozeman Trail. There were four captains under him—Franklin Fridley, John A. Cramer, John T. Lilly, and another. Here is John Lilly (center, sitting) with members of his family in later life. He lived in the area the rest of his life. Others shown in the front row with him are his son John and Colie Lilly (Minnie Terry's father). In back are Robert Lilly, John Hathorn, and Newton Lilly.

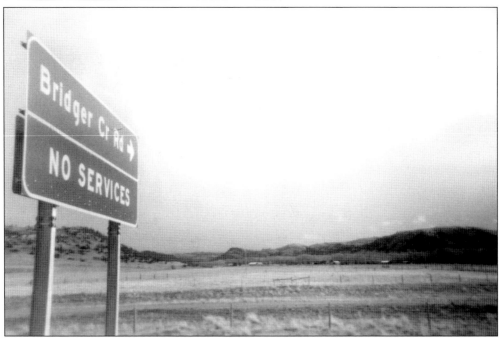

The point where Bridger Creek enters the Yellowstone River about ten miles east of Big Timber is well marked. Some signs note that there are no services available. Jim Bridger apparently met Bozeman Trail followers along this area to tell them about gold having been discovered in Emigrant Gulch, encouraging them to go there instead of on to Virginia City.

Two

YELLOWSTONE CITY

A site on the flat near the present dredge pond became the eastern-most town in Montana when snows in October 20, 1864, drove the miners down from the Gulch. One-story log cabins, topped with layers of pine poles, grass, and sod served as winter quarters for the men who had mined that early fall of 1864. This plat of the town was made on the grounds at an October 10, 1917 picnic attended by two of the original inhabitants—George Batchelder and David Weaver. There were descendants of many other residents attending. The Jack Conlins who lived nearby said they were invited. It was agreed that the McGorgil house was the first one built.

When I first saw the area in 1963 with Art Conlin, he could point out to me the streets. He said that the chimneys had been made from the black slide rock on the hillside between Old Chico and Chico Springs. With the heat it had turned a beautiful red, and there was a quantity that he thought would last forever. Even then we could find only very small pieces.

You will note that there was a ditch running along the lower side of the drawing. In it were indicated pools from which water was dipped for household use. Diaries of the town's residents say that they often went over to the as yet undeveloped hot springs to wash clothes for themselves.

I have a large map of this drawing that says on the back that it was given to the Public Library by Mrs. O.M. Harvey. It came to me from Edith Fodness Blakeslee in 1963.

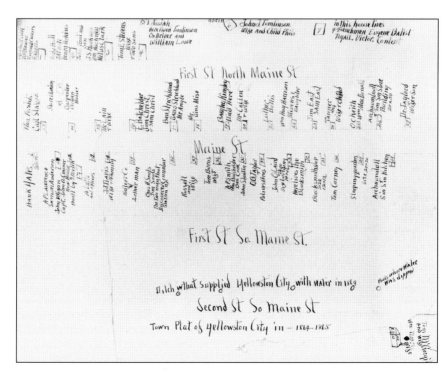

One of those who came with the Stafford Train on Bridger's route was Benjamin Strickland. Although he lived in Yellowstone City, he did little mining. He spent more of his time hunting and providing miners with food. He gained a favorable reputation as a mediator in troubles that developed between the Indians and the Whites.

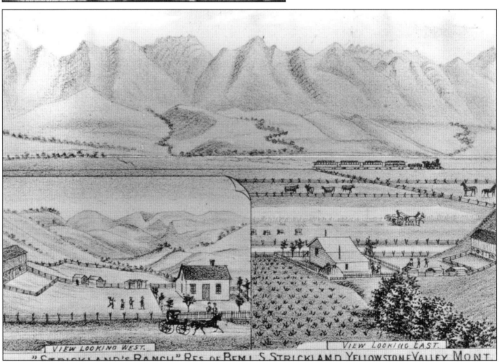

Ten years after Ben Strickland came from Iowa he took a homestead on the creek that bears his name. At one time the first creek above Emigrant was also called by his name; now it is Fridley. He married Nancy Jane Dailey, sister of Sam and Andy, who also took ranches rather than mined. This line drawing of his ranch is from Leeson's 1885 *History of Montana*.

Here at the Strickland home are, left to right: (seated) Ebenezer Dailey and Benjamin Strickland; (standing) Mrs. Ben Strickland and Silas Strickland (Ben's cousin) at the home buildings they had on Strickland Creek.

Dr. John A.T. Hull came with Stafford's train from Bridger's Waltman Crossing. Hackney said in his diary that he borrowed from Hull Milton's complete works in one volume to read during the winter of 1864 and 1865. Hull went to the States in 1865 intending to bring a herd of cattle to Montana but gave it up because of Indian hostilities. He remained in Iowa, where he was elected to several public offices.

The members of the Thomas Stevens family were among the first residents of Yellowstone City. Charlie and Willie Stevens were the only children to spend the mining seasons of 1864–1866 far up the Gulch in Shorthill District.

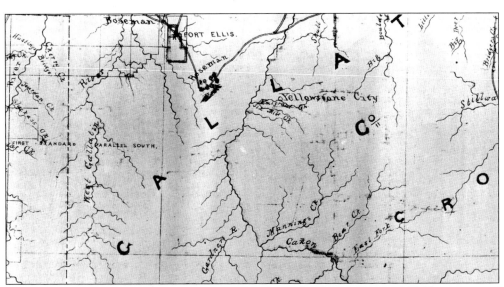

Walter W. DeLacy got paid $625 for the first map he made of Montana in 1865. The portion of the one made by DeLacy in 1871 shows the gold, silver, copper, and coal mines of the territory. This shows that Emigrant Gulch was located on the Crow Indian Reservation.

At one time, 20 tents of Indians were pitched across the creek from Yellowstone City. The tepee rings left show how Indians placed the inside layer of their abodes on the ground and held them down with rocks. The outside layer was loose so that a draft between the layers would draw out the smoke from a fire inside.

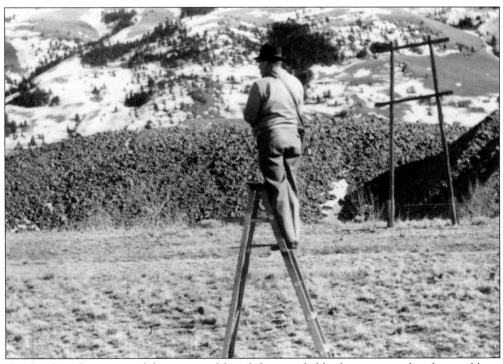

Our daughters have enjoyed this picture of their father on a ladder for no reason that they could understand. I spoiled their fun. I knew he was trying to equal the tepee ring picture I had got by climbing on top of the car when there was snow around the warm rocks, as my picture above shows.

To properly identify Emigrant Gulch for tourists on Highway 89, a sign should be more appropriately placed about four miles north of its present location. Before Emigrant Creek enters the valley it has been flowing from the south. See the map in the front of this book.

Margaret Tomlinson trained in tailoring and dress making in Iowa. She was one of 15 women in Yellowstone City that first winter. When they moved out to the sawmill site, she spoke of Mrs. Dailey swimming her horse across the river and coming "in my time of need." That would have been in April when Philo was born.

Otto Melin remembered his father going fishing down by the mill pond. This is Otto standing on the bank of the mill pond that Tomlinson built. He stayed with his mill on the Yellowstone River building boats for people who were leaving Emigrant Gulch and going back to the States because of Indian hostilities.

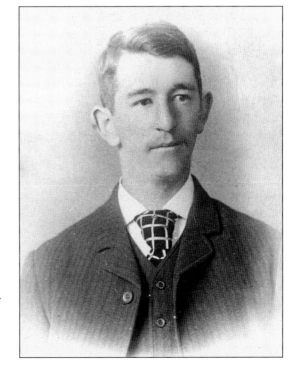

The Tomlinsons left the Mill Creek area in the fall of 1867, going to Bozeman and then to Salesville (Gallatin Gateway), where Philo and the other children grew up. Philo started a store there and was appointed postmaster on March 29, 1901. His family later moved to Walla Walla, Washington, where they and many other Tomlinson family members have made their homes since 1915.

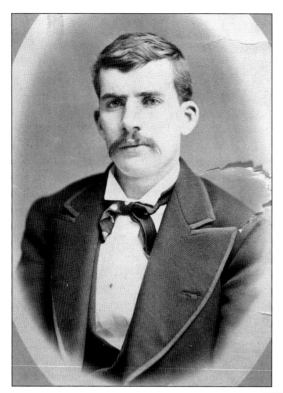

Coming back to the Yellowstone Valley after his first trip here in 1864, David Shorthill brought with him Joe George, who came driving one of the Shorthill wagons up from the South. Shorthill had taken his wife and eight children to Texas and New Mexico, but in 1880 he came again to stay on the Yellowstone. Joe George married Eleanor, one of Shorthill's six daughters, took a homestead, and spent much of his life in Park County.

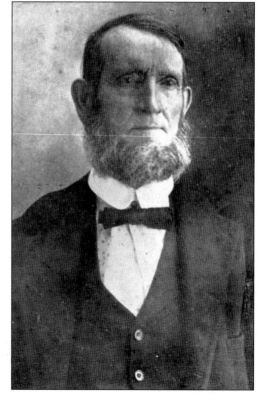

David B. Weaver came with Shorthill from Pennsylvania in 1864 and staked quite a good claim near Shorthills. He left for Helena and then returned to Pennsylvania where he held a number of political offices. He wrote of the early days in Emigrant Gulch for the Montana state Historical Society as well as for local papers.

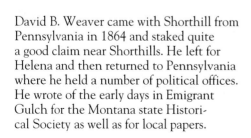

Three

OLD CHICO

In the spring of 1866 those living in Yellowstone City became hesitant to live there any longer and the entire population moved. Many left the Emigrant Gulch area entirely; others moved a little farther up toward the mouth of the gulch, thinking that would be a safer place from the Indians that were becoming hostile.

During the days of Yellowstone City's active life, the French traders Archaumbau and Sin Sin had been very good about warning residents of anticipated Indian troubles. Having the store, they had an ear tuned to local news and gossip. And they had not only the store but a kitchen and sleeping quarters for rent, as well as social gathering and dances at their establishments.

It was decided among those who wanted to stay with the mining after 1866 that they would build their homes at the very mouth of the gulch. When it came time to choose a name for their habitation, they remembered a little Mexican who had visited with a correspondent named Freeman, who wrote of the gold in Montana for a New York newspaper. The little fellow's name was Chico, and "Chico" was chosen for the name of the town that grew up at the mouth of the gulch. Previously, everything around had the "Emigrant" name attached, for the warm springs of the vicinity were first called "Emigrant Warm Springs." Eventually, they became "Chico Hot Springs," too.

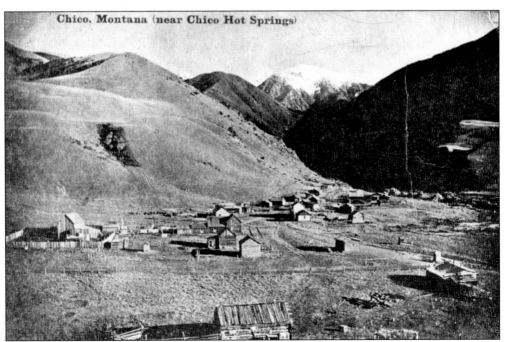

Chico, Montana (near Chico Hot Springs)

This is what Chico looked like about 1902. Emigrant Creek is to the right where you can see piles of gravel. A third of the way over is the small school with its one outside privy.

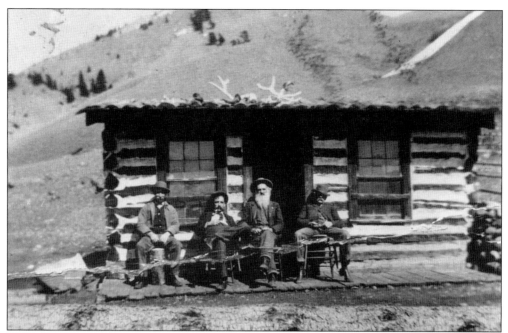

Shown on the porch of the G.W. Woods house about 1900 are storekeeper Chris Nelson, Gus Romer, Bill Cameron, and George Batchelderr, who lived in Chico from 1864 until his death in 1918. Woods was recorder for the Shorthill Mining District. It was at the doorway of this house that Clarence Keough and Carl Abrahamson killed each other in September 1925—a killing that left Aggie Keough with seven children, the youngest a bit over a week old.

Bill Cameron and Jack Fodness were true prospectors, always trying to find gold. I read in the paper that Cameron had come from Canada and received his U.S. citizenship in 1894. Now something is wrong. He would not have been entitled to a Civil War pension. And now, there is nobody around who can straighten out the facts. Or is there? Sometimes strange things come to light from unknown sources. Does anyone know anybody or anything about this?

This shows the flat that the Emigrant Consolidated Gold Mining Company owned for their operation in 1904–1906. To the right is the single outhouse that served the school.

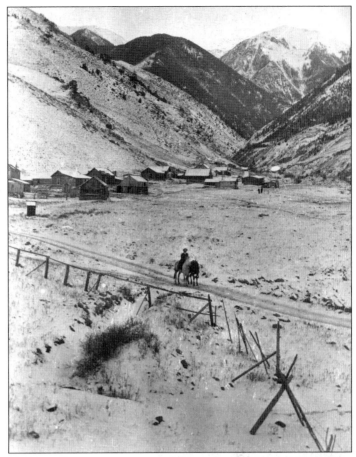

Jack Fodness and William F. Carr (always called Bill) were said to have lived in hope and died in despair. Fodness was called "Laggin' Jack," because he was so good at cutting laggins, the timbers by which mine tunnels were held up.

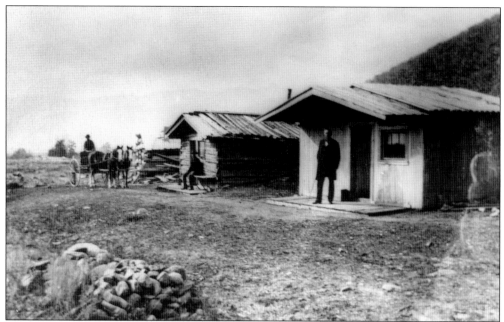

Frank Jay Haynes, the Yellowstone Park photographer, visited Chico in October 1885 and took this picture. For us the cabins and people are unidentified. This is from the Montana Historical Society's Haynes photos.

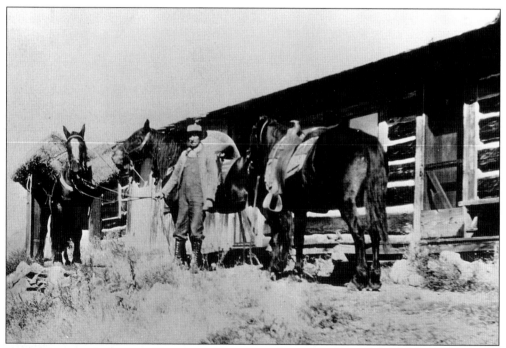

Jack Fodness packed up weekly to go to his claim above the Great Eastern on the righthand bank of Emigrant Creek. After the Fodness family moved to the homestead below Chico, it was a much farther trip than it had been from their cabin above White City. His claim was later held by Robert and Clarence Keough through the representation work done on it each year.

Robert Keough was always interested in the mines of Emigrant Gulch. Of the seven Keough children—Custer, Stanley, Clarence Jr.(Putt), Robert, Berniece, Geneveive, and Bill—only the latter is still living He makes his home in Portland, Oregon.

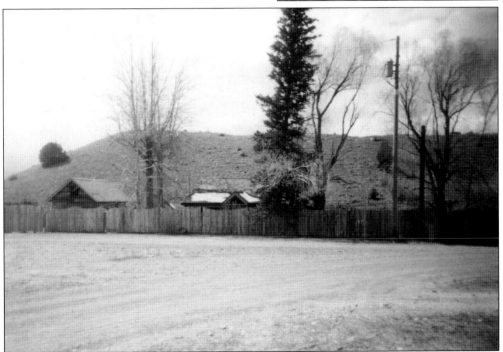

For several years now, Sarah Muller has lived in the old Billy Billman house. She helps out at Chico Springs when they need her. She is rebuilding the small tin-roofed building to be a guest house.

Albert McLeod lives in the house on the corner across from the schoolhouse. He moved there with his folks, Edward and Fannie, in 1938. His father worked around on several ranches until his death in 1960. Fannie worked at Chico Hot Springs for 24 years and several years for me at The Wan-I-Gan. She died in 1976. Albert has lived alone since that time. He worked for us as a handyman helper and on various ranches for many years. He has a car now, but for a long time he had three trucks and was the only driver.

This snapshot of Old Chico came into the Park County Museum during the 1960s. It shows that often times those seeking their fortunes by gold lived in rather squalid circumstances. However, hopes were always high and, though the comforts were few, pleasure was available in the simple things, like this lawn swing.

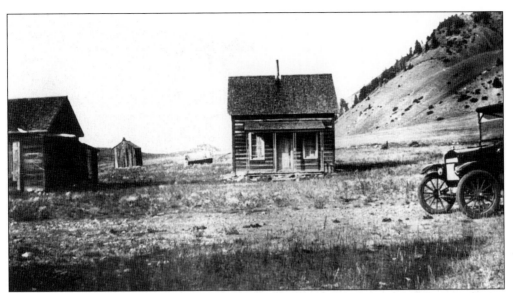

This is the house that Fred and Esther Billman bought about 1920. They made a very nice home of it with lovely flowers and a collection of nice rock specimens. The garage was converted to a workshop. The Billmans had two daughters and a son, none of whom live around this area.

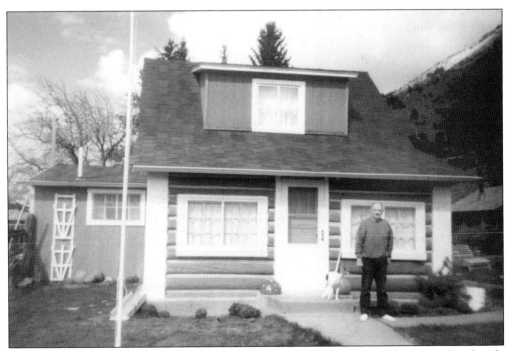

This is how the Billmans built that first little house up. Bob Meldrum, who is standing beside the house, makes log furniture in the workshop. He offers it for sale.

has this Day recorded Clame no 10 te
on the East Bar of Emigrant Gulch
Clame 16 Great Eastern lode
Shorthill District
G W Wood, recorder

April the 12 1877
This is to Sertify That D L Biam
hos this Day filed on Clame no 16
on the East Bar of Emigrant
Gulch Shorthill District
April the 18 1877
this is to sertify That D L Biam
has this Day recorded Clame no 10 16
on the East Bar of Emigrant
Gulch Short hill District
also the Gulch under said
Bar for Tump
G W Wood, recorder

June the 19 1877
This is to Certify That S J Mills

Dr. Don L. Byam filed claims in Emigrant Gulch in 1877. He moved to the Chicory Crossing on the Yellowstone. There his son Oliver and grandson Charles S. Muffly served as postmasters at Riverside, 1882–1883. Oliver died in a mine accident on Trail Creek.

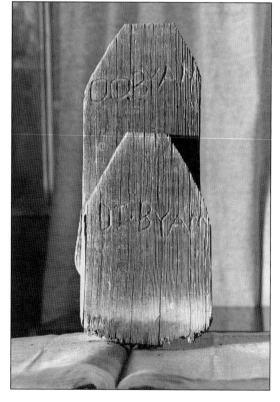

These pine slabs had marked the graves of Dr. Don Byam and his son Oliver in the Emigrant Cemetery. Oliver was killed in a coal mine on Trail Creek. They were preserved by Mrs. Eukes and given to the Park County Museum, where they are still on display.

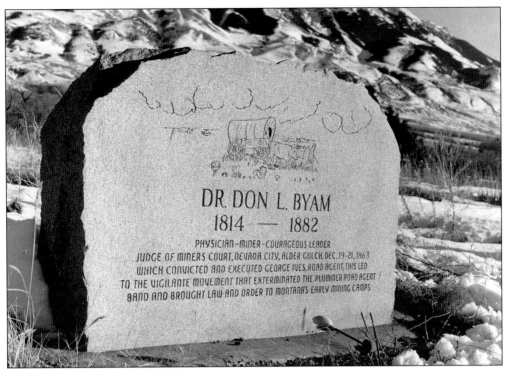

In 1956, this granite marker was erected in the Emigrant Cemetery to honor Dr. Byam and tell of his accomplishments as judge at the Nevada City trial that led to the hanging of George Ives and the organizing of vigilantes in Montana in December 1863.

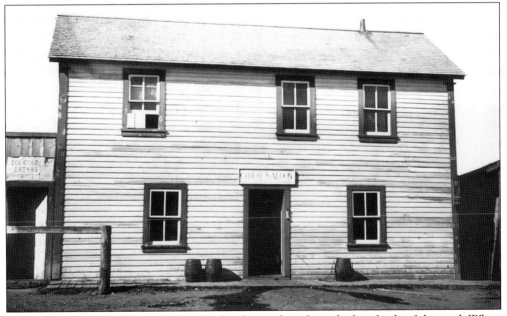

The big white house of the John Conlin family stood on the right-hand side of the road. When the mining company threatened to claim it, Conlin moved it across the road on a Sunday when there was no law to stop him. It served as a saloon on the lower level and the home upstairs.

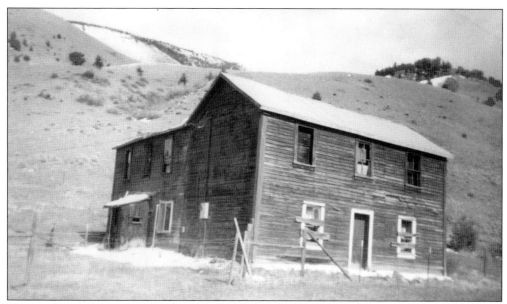

The big Conlin house has stood in Chico for many years with Brazingtons living there in the late 1940s while he was government trapper. The Orville King famiy lived there in the 1950s and '60s. It has been vacant for many years now.

This is the house that Arthur and Ruth Conlin moved into when they left the ranch in 1981. It was a pre-fab and here Ruth lives with two friendly dogs and a barn for her horse, since the death of Arthur in July 1986.

These five men had a nice studio picture taken together on one of their trips to Livingston. Pictured, left to right, are: (front) Herman Kahle, merchant and saloon man of Emigrant; John Clifford, once assessor and police judge in Chico; and John Locke, miner; (back) Charles Glidden and John Work.

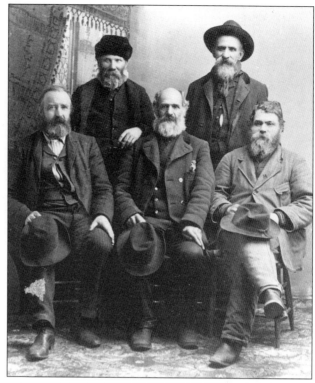

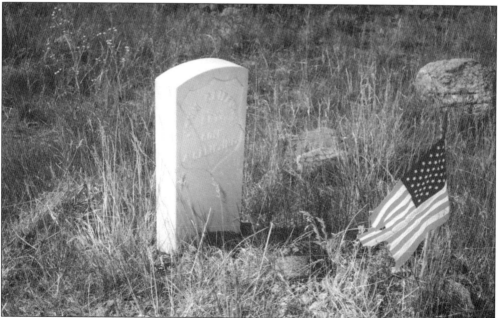

It was always said that John Clifford came to Montana with Marcus Dailey Butte's mining man. In August 1906 Clifford's sister came to visit him, but a month earlier he had fallen into the creek and drowned as he was getting water. The sister had also visited her brother in San Francisco after the Earthquake had wiped out his business. Clifford's grave is decorated each year by local veterans for his Civil War service.

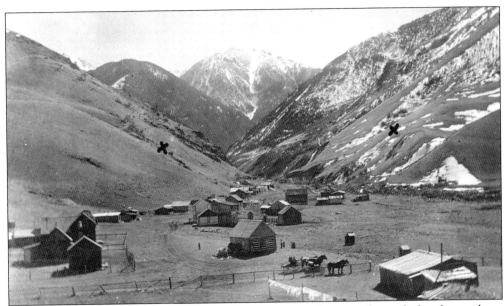

Here is Chico about 1910. The Xs on the hills show where forts were located after the residents first moved up from the Yellowstone City location. These had served as guard stations to alert residents to possible Indian attacks. From these locations it was possible to see all the way to the great bend of the Yellowstone.

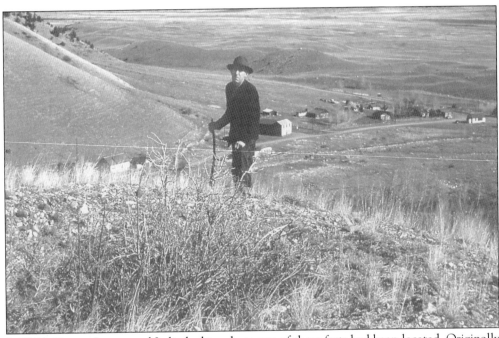

In 1964, George Larson and I climbed to where one of these forts had been located. Originally they were holes 8 feet long, 4 feet wide, and 4 feet deep. Stocked with food and water for a watchman, the residents felt safe from a surprise Indian attack. The two near Chico were named Fort Ella (Aylesworth) and Fort Betty (Mulheron). Another at the mouth of Emigrant Creek was named Fort Viola for Mrs. Bill Lee. Jack Conlin told me about these.

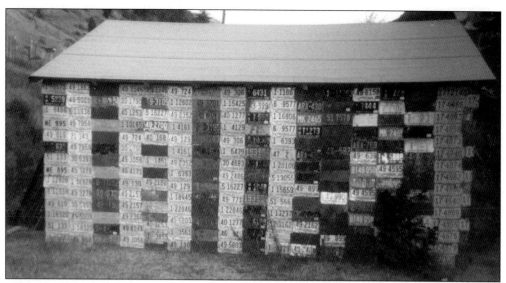

This old garage of Lundy Counts' always attracts attention in Old Chico. Lundy came to the area in 1939, lived in Emigrant a while, and then moved to Chico. When the King children moved to Livingston, he offered them 5¢ each for old license plates, and he got enough to cover his garage.

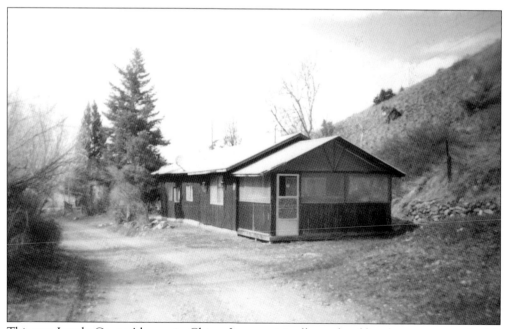

This was Lundy Counts' house in Chico. It was originally made of log, but was covered with lumber on the outside. The porch has been added by the present owners, who are summer residents. After Lundy died, his son Lewis lived here for a while.

For a long time Roy Harris' house would probably have been considered the best house in Chico. He did spend a lot of time at his mine on Slide Rock Hill, as well as at a cabin there. Here he had a good root cellar to care for the produce of his garden.

Nephews of Bill and Elvin Clayton have fixed up their cabin so that it looks very attractive. Frank Clayton lives in Livingston and works for the Forest Service. David lives in Billings and is a little less able to enjoy visits to Old Chico.

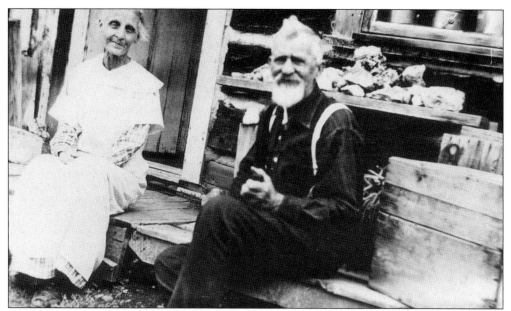

Mr. and Mrs. Lou Shafer lived down on the Yellowstone River just below the mouth of Emigrant Creek. Later they moved to Chico and he shared mining efforts with Charles D. Glidden. Mrs. Shafer was known as Mary Gillespie before her marriage. Jack Vink and Irene Allen both descended from that line.

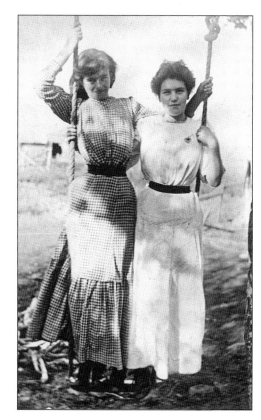

Nora Gregory and Agnes Fodness, residents of Chico, enjoy the pleasure of old and young alike. They are swinging on a board seat notched to fit the rope they hold.

37

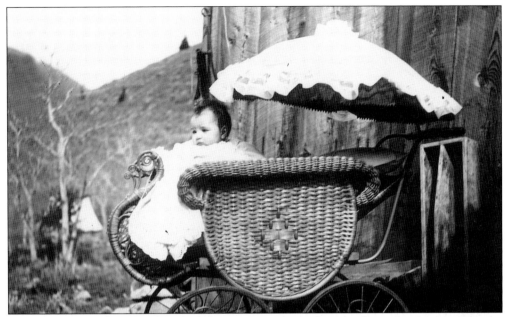

Annamae (Conlin) Peake identified this picture—the little girl is her sister Marie when she was two years old. Fancy carriage, wasn't it? Marie was born on September 10, 1906, and died February 13, 1908, according to the Chico cemetery records.

Jack Conlin came to Emigrant Gulch in 1899 and boarded with Percie Knowles. They lived in The Hollow before they built the hotel at Chico Springs. His first marriage ended in divorce. Asked in later life about his friendship with Mr. McAllister, he told me: "Mr. McAllister was my best friend. He took my first wife away from me." Jack took Annie DeVoe as his second wife. Her brother Charles was a photographer and left many glass plate negatives of people and activities in Chico. Here is Eva Queen with Annie.

The last occupants of this old railroad boxcar were Bryan and Sally Wells, who had bought some of the Conlin land. When the Episcopal Church in Emigrant decided to change their church hall, the Wells bought it and moved it to their land. Their first business was a wild game processing plant complete with refrigeration.

But they haven't stopped with that. Bryan has a cesspool pumping business and Sally has room for all her molds and her many outlets in the art field. She makes sculptures of animals, people, and anything requested, I do believe. The molds that she had must have covered a surface at least ten feet square. These are two sculptures of Chuck Yeager, who in 1947 was the first man to break the sound barrier. Animal drawings, paints, and sculptures have always been a favorite.

The old Mill Creek schoolhouse that stood near the Malcolm ranch has been made into a rental cottage for short term visitors, completely furnished so that the guests can care for themselves. This spring the yard was abloom with fruit trees—cherries, apples, and plums.

One of the most recent requests for Sally's art was a patio rock that the customer wanted an elk engraved on, and it was done to such satisfaction that he was going to bring another for a moose. Bryan was showing their work with pride—as well he could. It may be that they have found the Mother Lode in Emigrant Gulch.

Four

SCHOOLS AND CEMETERIES

That schools and cemeteries could be linked may seem like a strange pair of bed fellows. I feel the connection very strongly in my personal life, however. All four of our children attended school in Chico. The two who have passed on are resting in the Chico cemetery.

The first school building was a 14 foot by 18 foot log cabin, first thought to have been built as a gathering place for idle miners in the winter. But with the desire for a school building it was adapted to that use. One of the first pupils was 32 years old and several were in their 20s. A man by the name of Jesse Braden was the first teacher. He was followed by Ella Alysworth, daughter of the local storekeeper.

In 1914 a plat of the cemetery was produced by C.T. Sackett, a mining engineer of Livingston, showing 46 people who had been interred in the Chico Cemetery. Ruth Cameron had furnished the list. Four of them were dated as having passed away in 1864. Many of those listed were of the families served by the first school. There were some third generation families there.

My personal interests rest with my sons. Bruce had told Karen when they were going together that he wanted to be buried in the Chico Cemetery. She honored his request when he passed away at age 44 on April 11, 1986. His father-in-law made the grave marker, embedding in the cement some of the precious rocks Bruce had found as a boy. When Duane knew his time was short, he said he wanted to be laid beside his brother. Diana honored his request when he passed away on April 16, 1999. She had a lovely bench of Georgia gray marble made as his marker. Inscribed on the top is: "He Lifts Me up on Eagle's Wings."

I have sat on that bench and thought of the many times I have enjoyed going up the Gulch. Often I had hoped for eagle's wings. I had difficulty choosing which picture of Bruce's grave marker to show in this book. One showed his name plainly with his pieces of petrified wood. Several showed the Bible reference, Isaiah 40:31. That, like Duane's bench, speaks of our future when we mount up on angels' wings. One showed the deteriorating grapevine still in use. I finally chose this picture showing the good grapevine from their California home, which had been prepared by his family.

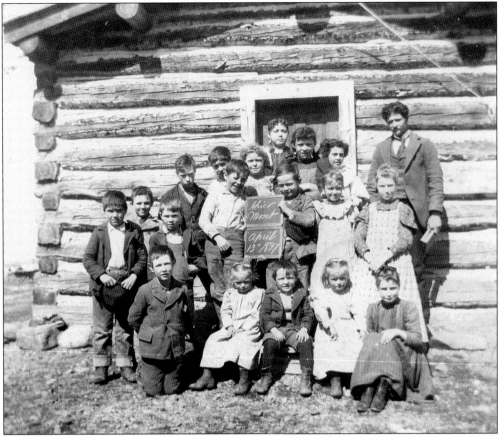

Shown here is A.W.T. Anderson and the Chico school on April 13, 1897. An *Enterprise* item on December 25, 1897, (yes, the local paper did publish on Christmas Day!) read: "Chico School will open again with Mrs. Vesta P. Walker as teacher." Anderson taught only one year. He became storekeeper and postmaster in Emigrant, a job he held until 1941. August Anderson was always called A.W.T.

> in the Register reads as follows. At the Election for Trustees held to day. A Controversy arose between Lou Shafer And G. W. Wood as to when this schoolhouse was built and was finally decided by Mrs. Lou Shafer that it was Built in the fall. of 1877 And that A Man by the name of Jessie Braden. Taught the first term of school

When Miss Maude Brown was Park County Superintendent of Schools (1911–1916), she prodded Bill Cameron into writing down facts of his former years as he remembered them. In 1975 County Superintendent Evelyn Rustad called these to my attention and I copied them. The script is hard to read, but I can make out most of it.

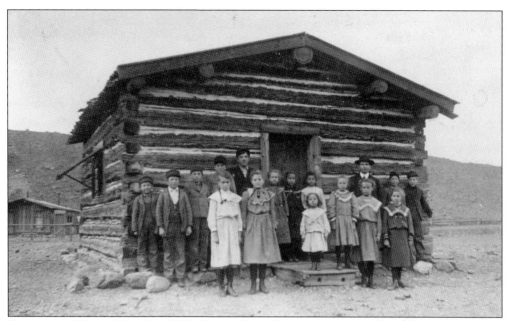

Here is the Chico School in 1904. Pictured are, left to right: (front) Agnes Fodness, Leora Weaver, Ella Fodness, and Ruth Bottler; (on the porch) Frieda Forman and Berniece Fodness; (back) Herb Marchington, Harry Marchington, Bertis Bottler, Bill Weaver, Stella Weaver, Esther Bottler, Lillian Marchington, teacher Ernest Shaferr, Bill Weaver, and Ernest Bottler. It was said that the kids called Mr. Shafer "Green Pants."

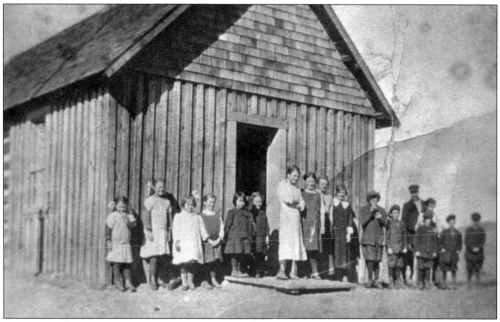

In 1908 with 17 pupils, it was time for a remodeling job on the roof of the old 14 by 18 foot school building. The roof was raised and a frame addition of 9 feet was added to accommodate the students at that time. I have no dating of the addition of the little covered porch. Jack Conlin furnished this photo.

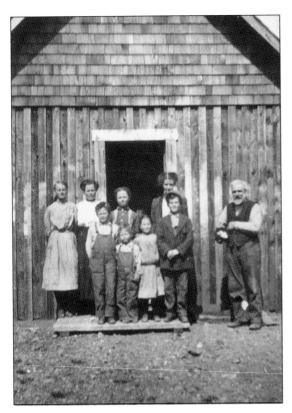

"Muggins" Cameron, a great favorite with the children, visited after school. Pictured, left to right, are: (front) Albert, Fred, Isabelle, and Bernard Billman; (back) Berniece Fodness, Josie Billman, Andy Billman, and teacher Ruth Mercier.

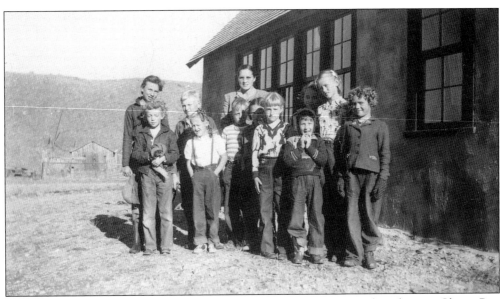

This picture is dated as 1949, the first of Hazel Peterson's four years of teaching at Chico. Pictured, left to right, (front) Evelyn Conlin, Sharon Counts, Bruce Whithorn, Jean Counts, Carol Whithorn, Billy Eggleston, and Patricia Peterson; (back) Margaret "Peggy" Conlin, Jimmy Anderson, teacher Hazel Peterson, Annette Conlin, and Barbara Counts. Note that in later photos the windows had been changed.

Hazel Peterson chose a Mothers' Day party for the last big party of her years as teacher at Chico. Those attending in this picture are hard to label, but much in evidence is student Darrel Brazington and the many mother visitors—Blanch Counts, Ruth Conlin, Esther Billman—you name them!

In 1954 there were no students living in Chico and it was decided to provide a school on Highway 89. The unused Six-Mile schoolhouse was moved. In 1955 there were only five pupils to take part in a Christmas program. I proposed to teacher Wanda Melin that I write a pantomime and the women of the district could be the actors. Here are Alice Mosness, Alice Kinkie, Rita Morgan, El Donna Pierce, Fern Lefgren, and Marge Miller participating in "Pa Puts Up the Christmas Tree." For the next seven years I wrote one for the school children to produce.

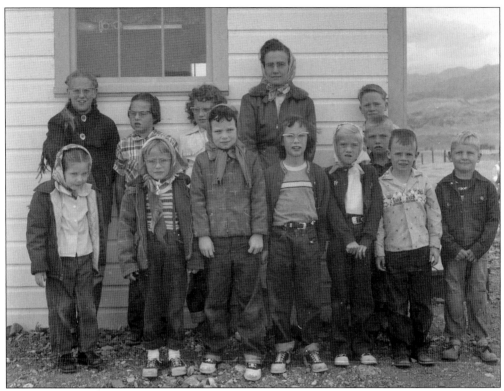

Wanda Melin taught one year in Chico and six years on Highway 89. Here she is with the students in 1956: (front) Vicki Peters, Colleen Anderson, Theresa Morgan, Karen Anderson, Kathy Volk, Jerry Rogers, Mike Morgan, and Donald Rogers; (back) Alta Whithorn, Sharon Peters, Nancy Kinkie, Mrs. Melin, and Duane Whithorn.

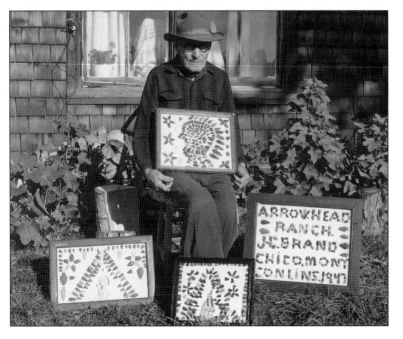

Jack Conlin came to the Chico area in the 1890s. He herded and raised sheep, married twice, operated a sawmill in Conlin Gulch, had eight children, and made these pictures of the arrowheads they found near the Conlin Ranch. He lived to be past 90, and enjoyed the party given him at the Emigrant Hall on January 27, 1963.

Seven of Jack's eight children gathered to celebrate their father's 90th birthday. They are J. Arthur of the home ranch near old Chico; Florence Amsk of Downy, California; Louise Benson of Camas, Washington; Naomi Armstrong of Moose, Wyoming; Charles of Clear Lake, California; Annamae Peake of Livingston, Montana; and Alice Templar of Washougal, Washington. Missing was Jerome of Ukiah, California. Many of his 53 descendants were present at the party.

Neighbors of 50-years acquaintance were among the well-wishers at his 90th birthday party. Pictured, left to right, are Floyd Nelson, Alice Armstrong, Fred Billman, Edith Blakeslee, Alvin Stands, George Larson, Arthur Brooking, Lester Busby, Elmer Armstrong, and Agnes Putzker. One lady who had lived in the community for 50 years did not gather with the group saying, "We didn't travel in the same circles."

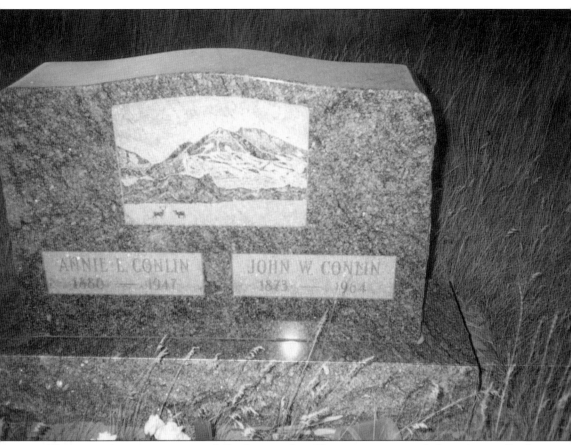

There are three generations of Conlins in the Chico cemetery, including Annie Conlin (1880–1947) and John W. Conlin (1873–1964). Many years of green moss was gathered several miles up the gulch for a covering of Annie's grave. Art's grave marker shows Emigrant Mountain, also. It was designed by his daughter Annette when he died July 16, 1986. Annette Conlin Geer was buried nearby at her death on February 15, 2001. Chico School was theirs, too.

Five

PLACER GOLD

The simplest means of placer (with a short "a" sound) mining is washing some of the gravel of a creek in a gold pan, as Jack Fodness was doing here in 1920. He was right in Emigrant Creek demonstrating the technique in this picture, which became a model of early placer mining. Placer is defined as a water-borne or glacial deposit of gravel or sand containing heavy minerals such as gold that have been eroded from their original bedrock and concentrated as small particles that can be washed out. The pan of gravel is rotated so that the excess water is thrown out. The heavier metal leaves a shining halo above the remaining gravel.

Jack Fodness was a prospector in Emigrant Gulch from the time of his arrival in 1893 until his death in 1931. For many years the family lived far up the gulch above White City. His three older daughters attended Chico school from there. They told of carrying Berniece down and back from school when she was small. By the time Edith was ready for school, the family had taken a homestead a mile below Chico at the mother's insistence. It was there I saw forget-me-nots growing and remembered them being picked for Susan Blakeslee's wedding.

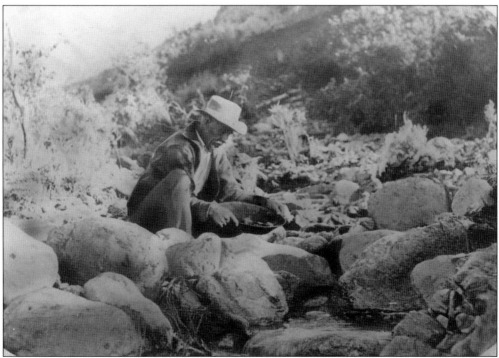

Here is your double dose of a great photo—Jack Fodness panning for gold.

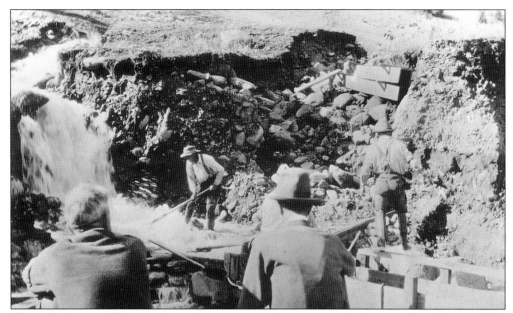

"Sluice" is "loose." "Ground sluicing" means using free running ditch water. Here Messrs. C.W. Roach of Los Angeles and Joe Swindlehurst of Livingston watched Jack Fodness and Fred and Henry Billman sluicing and shoveling the gravel into the sluice box at lower right of the picture. Dredging and hydraulic works were more complicated means of taking gold from placer diggings.

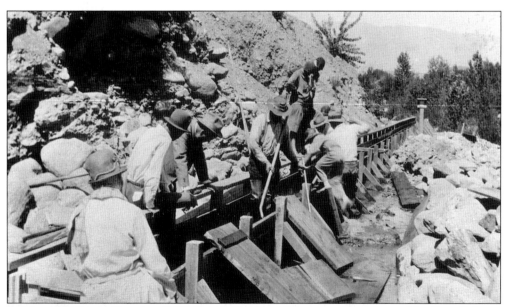

In June 1927 Percie Knowles, C.W. Roach, Joe Swindlehurst and members of the Swindlehurst family watched as Fodness and the Billmans worked at a sluice box on clean-up day. The water was shut off and the riffles (boards forming a false bottom) were removed so that the gold beneath could be taken out. Gold was often held in the rough boards.

This Emigrant Bridge built by Sohl of Trail Creek, at a cost of $8,500, replaced the toll bridge originally put in by Franklin Fridley to encourage miners to come to the Fridley-Emigrant area. This bridge served until 1949. Jim Gegan was representative of a Philadelphia company that had a contract to work with a big shovel in Chico. He said he would stay on the shovel while it crossed the bridge and the driver said the same. The crossing took an hour and a half.

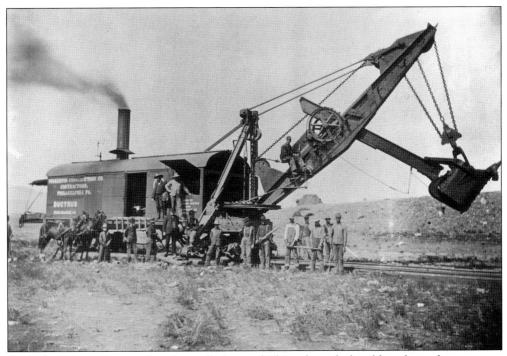

As the big 70-ton Bucyrus shovel travelled toward Chico through the old road past the cemetery, five lengths of track were laid ahead of it. When it had gone over them, they were moved on ahead of it. It took nearly two weeks to get to Chico. It worked right in the heart of town.

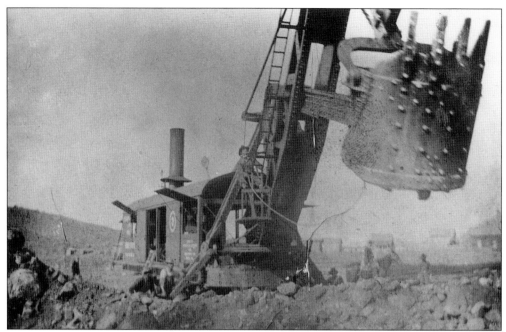

The Big Shovel worked right in the town of Chico. Under the dipper you can see the house that the Fred Billmans bought in 1920. The body of the shovel hides the schoolhouse. Each dip of the shovel had a 2.5-ton capacity, and two dips would fill an ore car.

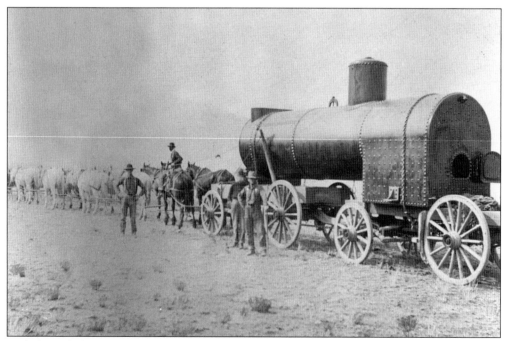

To help with the 1905 construction, Jim Bowen, known as "The Cayuse Kid," famous freighter of the Shields, spent the whole summer in Chico. His reputation was such that when a dude in Livingston said that no man could handle 18 horses and turn the outfit around on Main Street, Billie Miles, livery stable man, took the $100 bet and won.

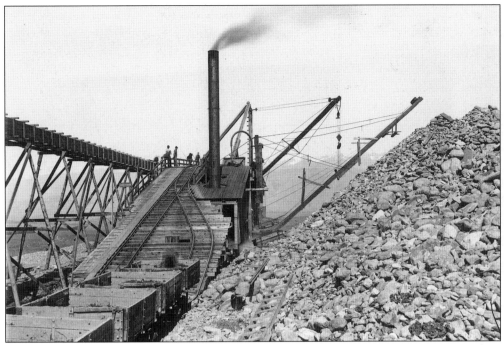

The 100-horse power boiler operated three hoisting engines and five other motors to do all the lifting in the washer. The cars hoisted up the straight track and after dumping, were released to descend on the curved shell. The first washer built in 1904 proved to be too small.

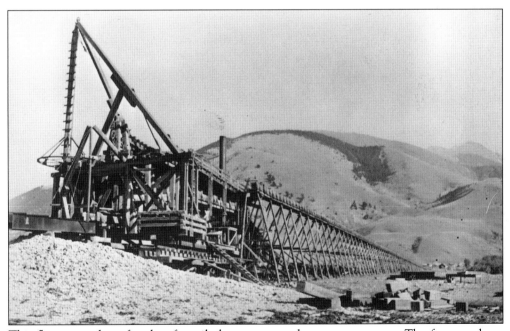

This flume was three-fourths of a mile long to serve the water necessary. The framework on which it was built was later used in the Six-Mile schoolhouse, where it was said that it was so strong that the building could have been rolled to its location on the highway where it later served the former Chico school children.

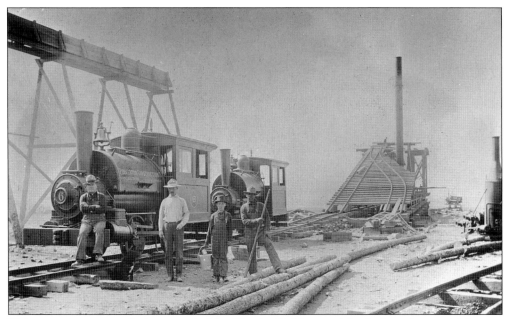

This operation was well photographed by Charles DeVoe on 4 by 5 glass plates, which were found in Jack Conlin's trunk after his death. Only the one plate of the unfinished shell had been developed—Jack Conlin gave me a printed copy of it. Jim Gegan was the man in the white shirt. There were 3 engines and 40 ore cars.

Mr. Pinkerton stands beside the dinkey and ore cars. Although he was to have been responsible only for getting the material delivered and into place, the Gold Mining Co. with stock mortgaged for $100,000 never took over. Without success he tried to collect the $35,000 due his company. Gegan ran the operation for 20 months and then it closed, broke. He died in Chico in 1907.

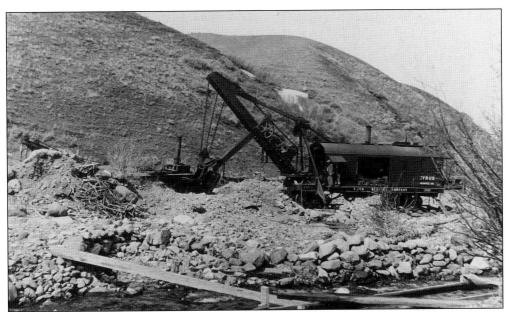

A second Bucyrus Shovel was brought into the town of Chico in 1912. It worked in the placers right in the creek. The school children called the bridge, which was still across the creek in the 1950s, the "Billy Goat, Bridge." They took this shovel out on the ice that was on the Yellowstone River that year.

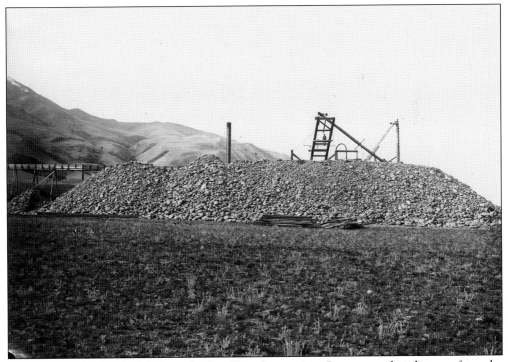

This is the pile of rocks left from the Big Shovel operation. It now stands a distance from the dredge rocks added in the 1940s. It is near the tepee rings pictured earlier in this book. There are many more tepee rings farther south toward the settling ponds made for the dredge operation.

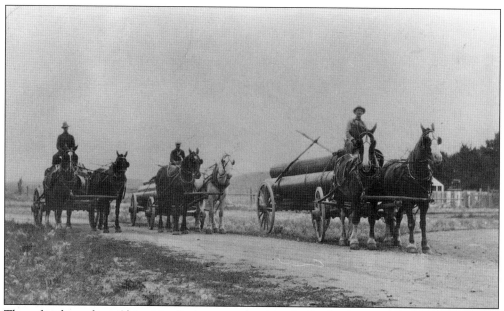

These freighters from Chico Hot Springs were hauling this hydraulic pipe into Emigrant Gulch for use of the Hy-Grade Mining Co. The largest pipes were 20 inches in diameter and gradually reduced in size to come out with high pressure in a nozzle that was probably four inches in diameter. The drivers are Harrison Adams, Earl Laffoon, and Fred Billman.

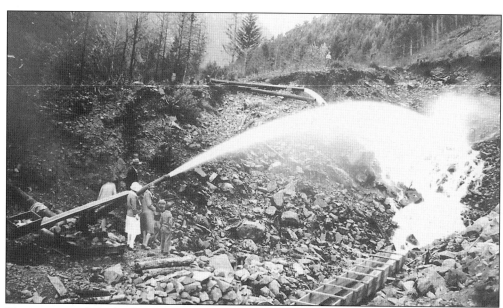

This was a simple hydraulic operation that several miners used in Emigrant Gulch. They washed the loose rock down with the force of the water under pressure. Bill Carr had a giant hydraulic that he displayed in his advertising book. It had much more force than this one pictured here.

Mr. and Mrs. Billy Billman worked for W.F. Carr during much of his time in Emigrant Gulch. Here they are at their home in Chico. During their later years, it was not uncommon to see Billy in his garden with a crutch that he leaned on while he worked and then used it to move to a new location. They raised a family of 10—6 boys and 4 girls. Edith died in May 1950 and Billy in December 1951.

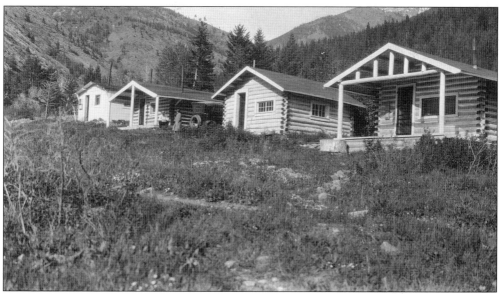

Carr built the cabins of White City about 1920. They served his miners until his death in 1934. There was another cabin on the creek bank below. There is only one cabin left here at this time. It is evident that fire reduced the number, for I was there June 22, 2002.

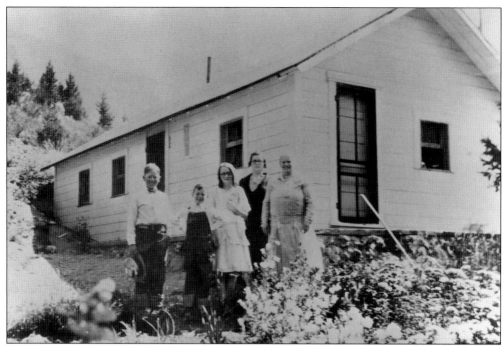

When the Hy-Grade started its work, this house was built for Edith Billman to serve the miners who lived in the cabins on the upper side of Balm of Gilead Creek. From 1920 until Carr's death, Billy and his sons George, Henry, Henry, Bernie, Albert, and Fred worked for Carr. Judd Hossfeld and Josh Colley also worked for Carr.

This was the boarding house where Edith Billman's daughter Josie Drake and family served the men of White City. The garage and boarding house were below Balm of Gilead Creek; White City was above. Note the dinner bell on the garage. A rustic "Chapel in the Pines" was built in the trees behind the garage by Tommy Thomas of Billings, who used the area for summer recreation during the 1970s (I believe).

In 1939, the Crown Company operated this machine in the lower placers. Sometimes called a dry-land dredge, its recovery system was like that of a dredge in that the crane dropped the dirt onto a grizzly, which threw off the large boulders and processed the remainder of the gravel in a trommel. It worked only the top 12 or 15 feet. The stacker end and trommel are off to the left. Note the size compared to the man on the platform.

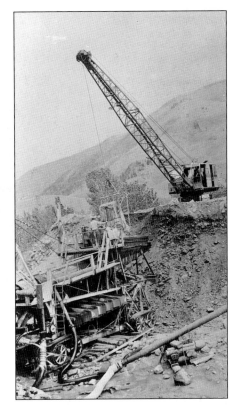

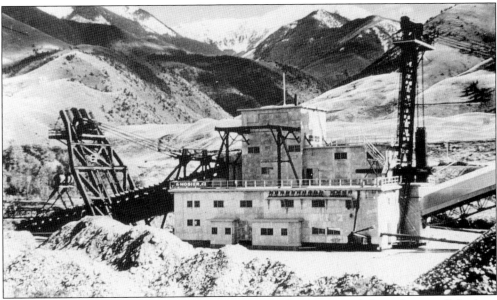

This is the postal card we found at The Wan-I-Gan when we moved there. It cuts off the long stacker. This Mosier II was the largest dredge ever to work in Montana, and cost $600,000. It was shipped in from Yuba City, California, and reassembled about three-fourths of a mile below Old Chico. From mid-August 1941 to October 15, 1942, it treated 1,616,668 yards of material. Recovery averaged 14¢ a yard in gold. The government restricted gold mining during WWII.

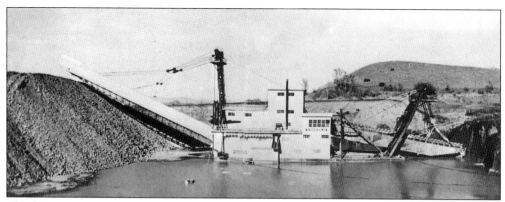

This barge was 170 feet by 70 feet. It floated in the pond it dug. During its first period of operation it took gravel 90 feet deep. One of the 110 10-foot buckets dumped each 20 seconds on the grizzly. If a large rock started up the stacker, it was covered with a mattress and broken by dynamite. It operated again from April to September 30, 1946, and treated 947,320 yards. It was pulled up to work only 45 feet deep. Operating profit in 1941–1942 was $67,000. In 1946, losses were $13,329. Figures are from Montana Bureau of Mines, 1987.

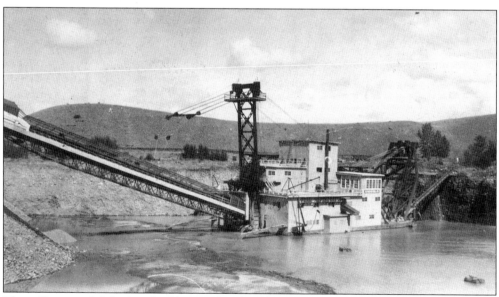

The tailing trough left a beach of fine sand at the edge of the dredge pond. Local swimmers have enjoyed this beach. During the time the dredge was not operating a watchman was on hand to break the ice that formed on the pond, since ice could crush the structure.

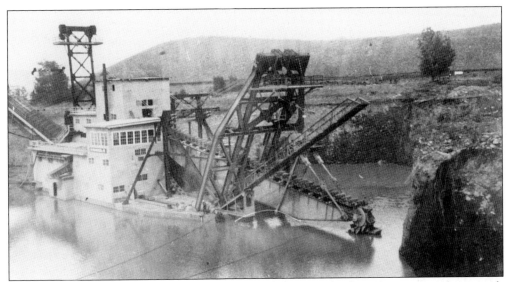

Many local people have enjoyed swimming in the dredge pond, where the water is of a greenish color. At one time a horse drowned in the pond. In November 1998 a stolen truck was pulled from it. In November 1947 the dredge was sold to Nechi Consolidated Dredging Co. of Vancouver, BC for $400,000. We were told it was taken to South America to work.

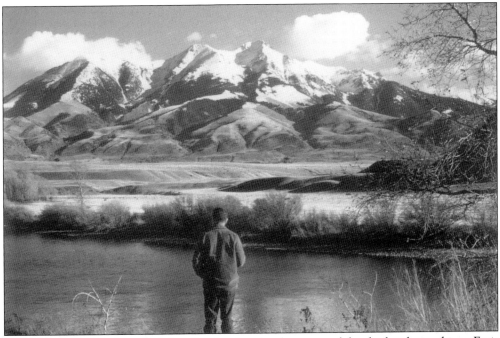

Local residents complained of the silt stirred up by the water of the dredge dumped into Emigrant Creek and thence into the Yellowstone River. Ranchers said that their irrigation water was so loaded with sediment that it coated the bottom six inches of plants. Sportsmen said that the heavy deposit endangered fishing 20 miles downstream. A series of 13 settling ponds were built south of the dredge for the silt in the water to settle. They are still visible, but those living along the Yellowstone River are no longer plagued by the silt.

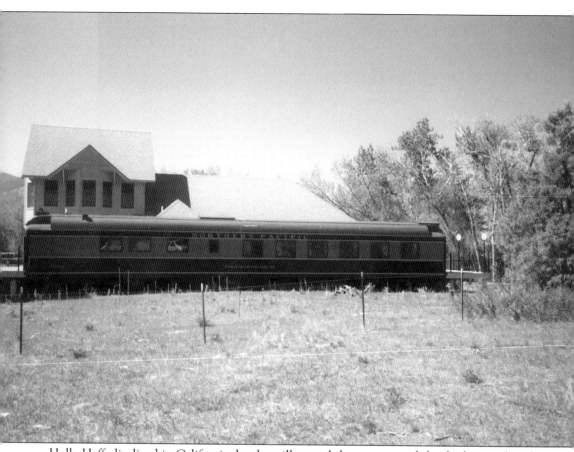

Holly Hefferlin lived in California, but he still owned the area around the dredge pond at the time of his death. He had obtained a railroad dining car that he expected to have refurbished and brought to lower Emigrant Creek. His children carried out his wishes and added to the dining car a large building to be considered a section house for railroad characterization.

Six

LODE MINING

The first and simplest method is to mash up the rock with a hammer or sledge in a bucket, a small amount at a time, to see if there is any gold or silver in the material. The resultant finer rock would be washed around in a gold pan, just as the placer gravel was, to try to separate the good from the bad. That is a simple operation for a small sampling of rock, but any large amount would require much more exercise.

In the first place, lode would likely be stuck back in a hillside where a tunnel would have to be dug to get any desirable amount of material. There would have to be means constructed to bring the rock out of the tunnel as well as getting it broken up. This would sometimes entail trackage and ore cars. Some of those might require beasts of burden being employed.

Often very large plants with heavy stamps were built to do the smashing job. Sometimes rolling mills with heavy steel balls rolling around among the rocks would accomplish the crushing. Then the gold or silver would be separated with chemicals such as arsenic or cyanide for which special plants were often built.

Many arrastras were built in the backcountry. They were a bed of rock on which a wheel ran around to crush ore. Sometimes the wheel was powered by man and sometimes by horse. Wheelbarrows were made on site.

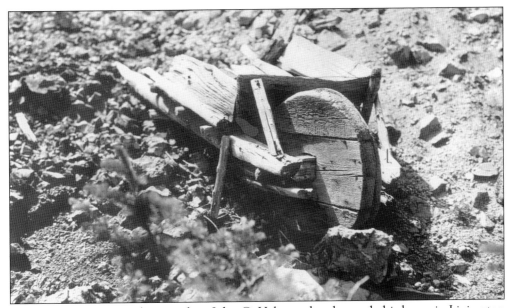

A well-known western photographer, John C. Haberstroh, who made his home in Livingston for many years, found this wheelbarrow abandoned in the upper regions of Emigrant Gulch and thought it worthy of attention. Many of his photographs appeared in national publications.

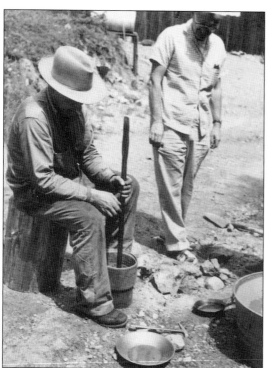

Mining lode gold is a matter of breaking up the rock containing the precious metal in some way so that the gold can be retrieved. Here is Huntley Hardgrove, an old prospector, hammering up some ore brought from near Norris, Montana, so that it could be panned. Lode is usually not the first gold found in an area, for discovering it often requires digging tunnels into the hillsides where it is believed to be. Often its presence is revealed by fragments being washed down from a body of hard rock.

The 1900 Livingston *Enterprise Souvenir* tells of Frank McGuire accidentally discovering a rich quartz lead while on a hunting trip up Six Mile. While gathering wood to build a campfire, he found a piece of float that he and his brother later mined successfully with 200 and 300-foot tunnels that yielded ore that netted $50 per ton in gold and silver.

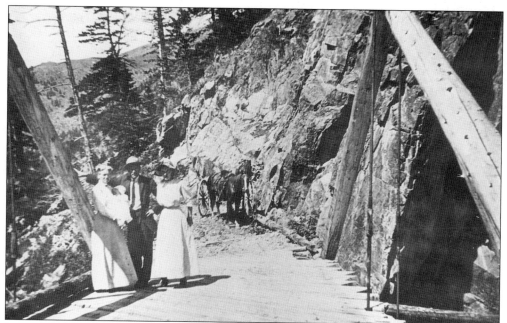

Lark Dunn and his brothers-in-law, Marvin and Manley Fountain, built this bridge over the first falls in Emigrant Creek. With a rolling of rocks heard even to Chico, it was washed out by high water on June 11, 1918. Scars of the old road serving this side of the creek can still be seen.

Somewhat below the location of Lark Dunn's, a bridge made of an old railroad tank car serves to cross the creek. Almost immediately after this creek crossing, there is a steep hill that now requires four-wheel drive vehicles but could once be made by Model Ts. The entrance to the Ice Cave, which was above this, has caved in.

November the 24 1875

Shostile District May 19 1875
Know all men by these presents
That We G.W. Wood and W.J. Gray
For this Day Sel to Cone and Clifford and Lee
The folowing Described mining
Clame to Wit Comensing at the
Center of the Big Bolder
and runing up the criak in a Strate
Line to a stump marked Standing
on the rim that Devides the Bay
from the criak Embrasing All
that part on Said mining Clame
Lying West of Said Line being
all the West half of Said
Ground from Said Bolder
To Cone Clifford and Lee
Ground for the Sum of Seventy five
Dollars in hand paid this
receipt is acknowledge
G.W. Wood, W.J. Gray
G.W. Wood, Recorder

I have the 1874–1878 mining claims book in my possession. A portion of G.W. Woods recording on November 24, 1875, gave to Cone, Clifford & Lee "the folowing described mining claim to wit comensing at the center of the big boulder and runing up the crick in a strate line to a stump marked standing on the rim that divides the bar from the crick. . . . " The stump has long since disappeared.

October 17, 1986, was a beautiful fall day to walk up the Gulch. Bobbi Sackett, my grand daughters Melanie and Lindsay Orr, their friend Cathy Hicks, and I went as far as the Big Boulder. Cathy climbed it.

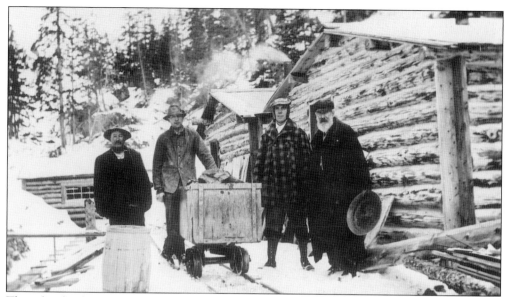

These hardy old-timers were beside the twin cabins about a mile farther up the Gulch. Written on the back of the original: "Thirty-two below here last Sunday. Shown are Billy Billman, Judd Hossfeld, Bill Carr and Bill Cameron. They represent the three types of men seeking gold. Billman and Hossfeld were mining for a wage; Bill Car was a promoter, who brought in outside money; Cameron was a prospector—just wanted to find it."

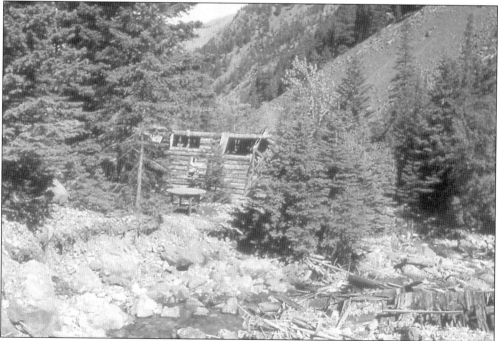

The twin cabins were still recognizable when I went up the Gulch in 1970 and took this picture of them. Since that time they have fallen down completely. In 1917 ventilating machinery was installed in the Carr mine here. Another of Carr's projects was digging 400 feet deeper into the Ice Cave after buying it from Knute Knutson for $400.

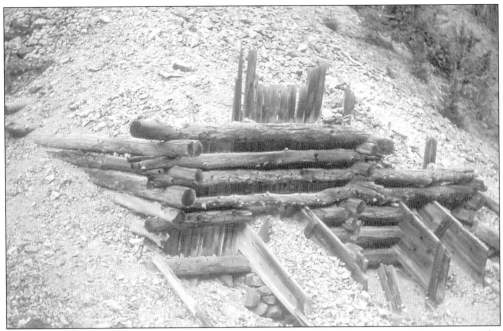

In recordings of the 1870s many claims were located below or above the Great Eastern. The area is still so labeled. The county road ran to here in 1885, but miners extended it in 1888 to the forks of the creek. In 1895 it was noted that five carloads of ore were sent from here to Butte for a smelter test.

In the fall of 1883 there were plans to build a smelter near the Section House at Chicory, two miles north of Emigrant. There was a ferry at Chicory. Plans called for a 24 by 30-foot building, but the smelter itself would be outside with a 40-foot stack. A temperature of 1,500 degrees was required to melt the silica from which the metals were to be separated. The plans did not materialize. Here is tomfoolery at the section house at Chicory.

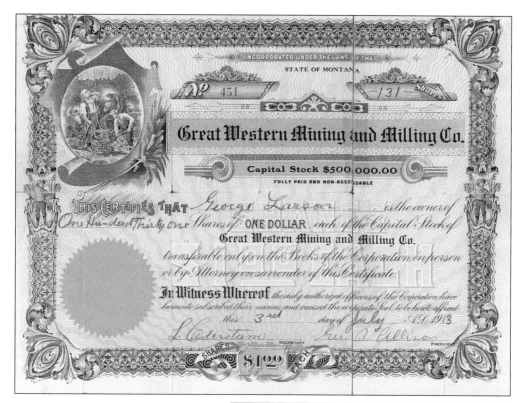

On our October 3, 1963, walk up to the St. Julien, George and I stopped at the Allison Tunnel. Knute Knuteson had started running it 200 feet deep by setting a charge of dynamite each evening and clearing it out the next day. Allison bought it in 1910. George and his twin brother Peter bought it from Allison. They sold it to A.W.T. Anderson, who sold it to a Butte man who hand pumped the bad air out beyond 200 feet. This is the stock certificate George got from Allison.

George and Peter had brought some old ore cars over from the St. Julien, which had closed. They worked there the winter of 1913 and slept in tents —four beds to a tent with a stove in the middle. It was very comfortable, George said.

George looked at the streak of molybdenite that had been left on the hillside from trials at trying to process it at the mouth of the tunnel. Later it had to be taken to the plant down the hill where water and oil for processing were available. Allison was never really successful at getting moly from the tunnel named for him. Government men looked into the prospects here in 1917.

Knute Knuteson lived up the East Fork about a quarter mile. As we approached his cabin area, George said that we would be nearing where he had lived. Sure enough, there was a big slab of rock as his doorstep and the remains of a stove in the area. There was also an outcropping of copper, which George had remembered.

I did not go to the site where I had heard that there were remains of an arrastra used by Bill Knowles. I knew Al Basler, one of our young boarders, was going up the main fork of Emigrant Creek to that area, so I sent my camera along with him. This shows a part of the wheel that crushed the quartz.

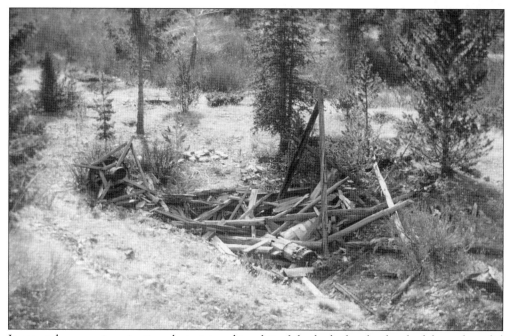

It may take some imagination, but pictured is a bit of the bed of rocks that had formed a solid floor for the heavy wheel to crush lode some 80 years before this remained in 1964 on Al Basler's trip up the main fork of Emigrant Creek.

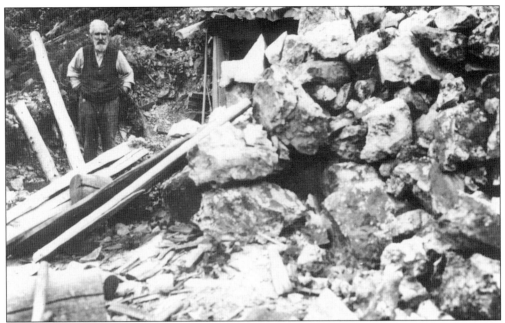

This is W.D. Cameron and his molybdenite claim on Emigrant Creek, as photographed by F.L. Hess of the U.S. Geological Survey Company. Molybdenum is a blue metallic element that resembles chromium and tungsten in many properties, and is used in strengthening and hardening steel.

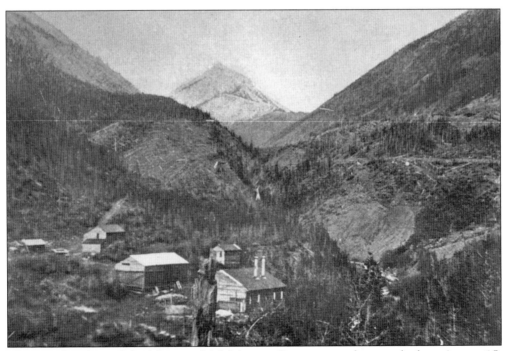

This was the plant of the Montana Molybdenum Company as photographed on August 15, 1917, by U.S. Geological Survey Co. photographer F.L. Hess. Mineral Mountain is in the background and a bit of the high falls of the main fork of Emigrant Creek is shown below it.

On July 28, 1935, a fire broke out that destroyed Kearns' buildings and spread to a total of 1,500 acres, whipped by quite strong winds. A hundred fire fighters were on the job until Thursday. Of unknown origin during the dinner hour, it was suggested that some fumigation done might have set off a spark from the water heater.

FIRE DESTROYS EMIGRANT GOLD MINING CO. BUILDINGS

Flames Spread in High Wind to Forest, Burning 600 Acres in 1,500 Acre Area by Monday; High Wind Fans Fire Out of Control Again Tuesday

Fire broke out at noon Sunday in the bunkhouse of the Emigrant Gold Mining company far up Emigrant gulch destroying all of the mining company's buildings and other property above ground, and setting fire to the forest on both slopes of the gulch.

The fire had attained an area of 1,500 acres Monday morning, with 75 fire fighters on the job. The flames were brought under control during Monday

drift placer mine controlled by the Emigrant Gold Mining company for several years with fair to better success and the fire loss will be a considerable handicap in operations for the near future.

Flames Flare Up Anew Tuesday

A cyclonic wind rose from the south in midafternoon Tuesday and gave the flames a new start, and Tuesday evening the fire fighting crew had been increased to 100 men in an effort to

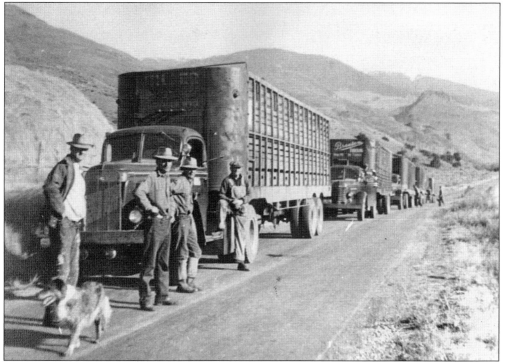

Worth L. Kearns was truly a part of the Emigrant community for several years. Shown here with Dave and Vince Rigler and a truck driver for Nunley's, he had been with the Emigrant Bank at the time it closed and then moved to Gardiner in 1925 to work at the bank there.

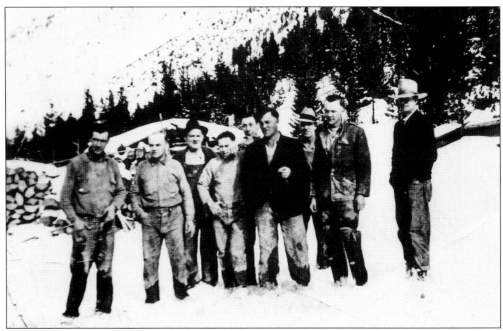

This picture shows a Kearns mine crew in 1935. Pictured left to right are: Bill Vanderpool, un-identified, unidentified, Dan (?) (foreman from Butte), Frank Ashley, Scott Melin, and three more unidentified people. Obviously they worked in the snows of winter, which came early in the mountains. The shop and head of the tunnel were under cover.

Kearns rebuilt some of the cabins. He gave Roy Harris a bill of sale for the cabins and the ore cars. Tom Sutherland pushed the ore cars down into the creek. One was retrieved from the creek bank for the Park County Museum when I was caretaker there in the 1970s.

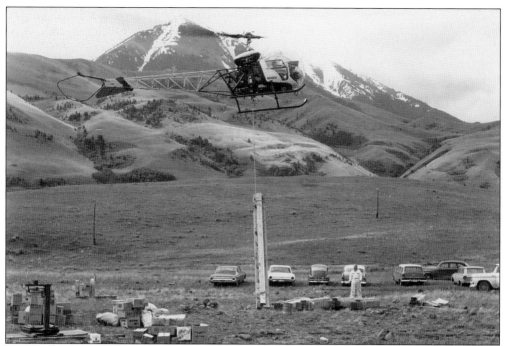

In June of 1963, the American Climax Company, which had shown an interest in Emigrant Gulch in 1937, 1961, and 1962, hired Boyles Brothers to take out core for examination. From a flat across the creek from the dredge rocks, Boyles Brothers sent their helicopter to the two drill sites. It took 15 minutes for a round trip of supplies weighing about 750 pounds.

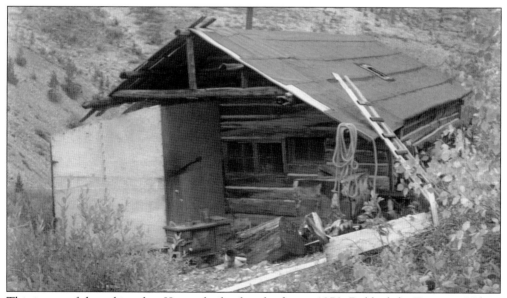

This is one of the cabins that Kearns built after the fire, c. 1970. Dubbed the Emigrant Hilton by the Climax crew of site #1, this cabin served as their home from June 12 to September 17, 1963. There was an outdoor privy with a regular toilet seat around the rough-sawed hole. The addition was the shower room, served with sun-heated water. They had refrigeration and propane cooking facilities.

Robert Applegate was the geologist for American Climax. His wife Bonnie spent much time in the field with him. They lived in one of our cabins at The Wan-I-Gan. A later job took him to South America, where he lost his life in a mountain fall. She returned to the U.S. with two native children they had adopted.

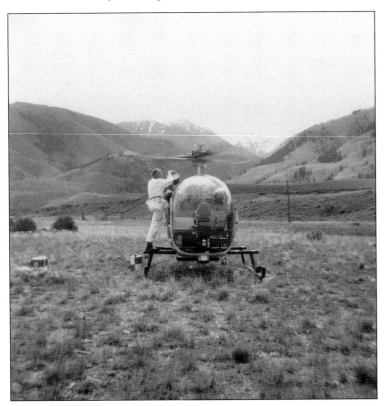

The Bell Helicopter had two gas tanks, which held a total of 41 gallons. The copter had to stop every other trip to be refueled. If the pilot did not have to land, his load could be hooked on as he hovered. Charges were 6¢ per pound for freight. Human cargo was $120 per person.

The crew at the #2 drill site on the third peak of Emigrant Mountain at the bottom of the bright streak had these commodious abodes for their bedroom and dining areas. There was only a foot trail to their campsite. Tommy Doyle, retired grill owner and cook from Livingston, prepared their meals.

The crew at the #2 site did have one modern convenience unavailable to those at the Emigrant Hilton—a telephone at the lower end of the trail. It afforded them the opportunity to find out any necessary information before climbing the hill on shanks ponies.

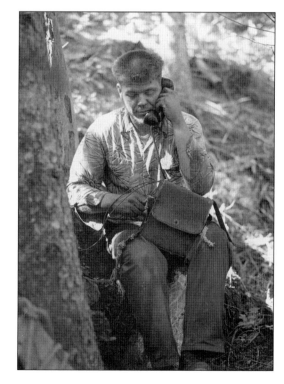

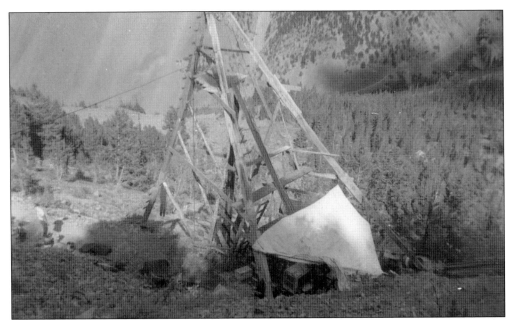

At #2 they drilled and took out core to a 1,200-foot depth. They hit an artesian water supply that came out at 200 pounds of pressure. Drilling had to be stopped. Someone who visited the site about 10 years later said that water was still flowing from their drill hole.

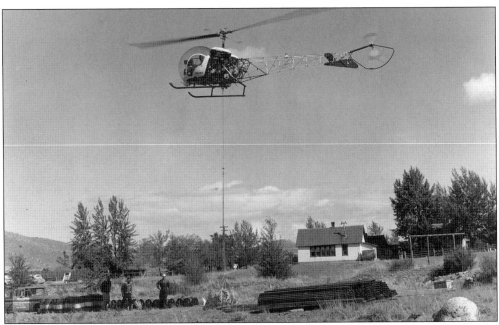

Plans were to ferry out on September 16, 1963, anything that was worth 10¢ a pound to a copter port near the old school house in Chico. But that day the wind came up and made it too dangerous for the chopper to descend in the narrow canyon. Bill planned to take pictures on the 16th, but he had to work in Yellowstone Park on the 17th, leaving me to fly up with the crew and snap pictures. Bill's darkroom work gave them what they said were the best enlargements they ever had.

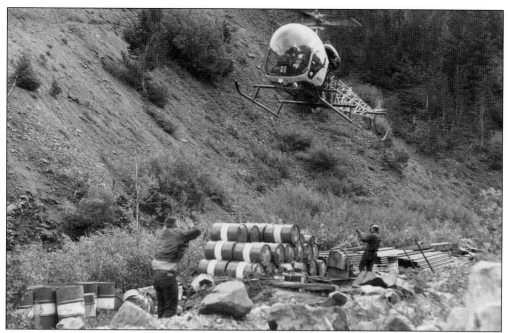

Gasoline was 25¢ per gallon in 1963 but by the time it was carried out it was worth $1 per gallon. Since it could not be dumped, the workmen had a ticklish job hooking up the barrels while the pilot hovered in the narrow canyon. They inserted a capped pipe into the drill hole, which totaled 1,505 feet deep.

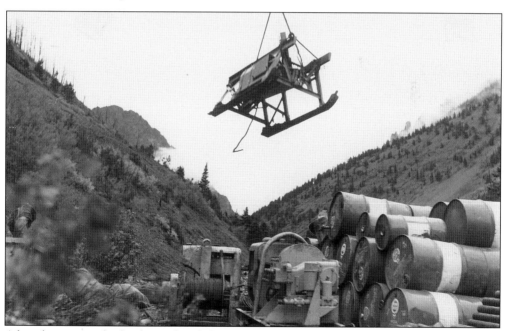

After they put a sky hook on this drill frame, which weighed only 640 pounds, I decided I wanted to wander into the Gulch a bit more, but I did not get to the St. Julien as I had hoped. I finished my job at the #1 site. This drill frame was mounted on steel runners for pulling to inaccessible sites.

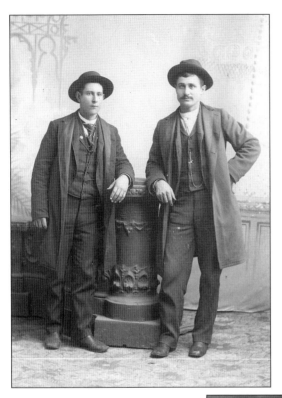

Joseph Stands came to Montana from Ohio in April 1890. His first interest was in mining. He worked a claim on Slide Rock Hill with Peter Bair. The latter stayed with mining longer than Joe Stands did, for I have a book that shows he had a grocery account in 1896. A later news item said that Peter Bair was sent to Warm Springs, the Montana State Mental Hospital.

After Joe Stands left the Slide Rock Hill claim, he went to work for Daileys, a ranching family, where he worked with cattle and cooked for crews. Next he took a homestead in Stands Basin, which along with Stands Peak is named for him. He married, but the homestead was too high for Molly. He took a homestead on Six Mile Creek and lived there the rest of his life.

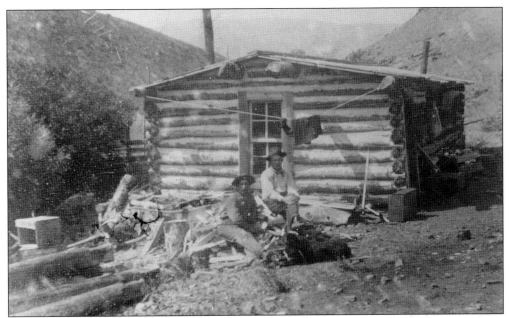

This is the cabin in Stands Basin that Joe and his brother Frank built. Later surveys found it to be 300 feet off of Joe's land. After Joe and Molly were married on April 20, 1907, in Helena, they built a nice cabin on the railroad section he bought in 1893 for $1.25 per acre. It was at an elevation of 7,000 feet.

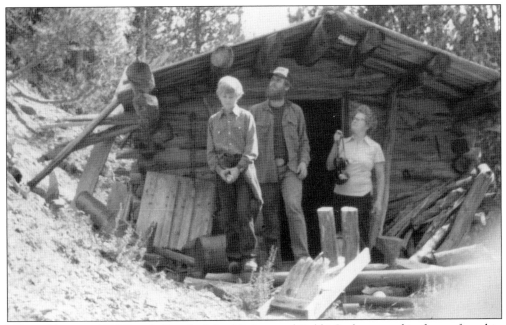

Pictured here in 1980 Randy Stands, John Vining, and Bobbi Sackett stand in front of a cabin across the slide rock from Joe's former claim. Randy is a great grandson of Joe Stands and a grandson of mine. This cabin was later used by Roy Harris, who worked the claim that Stands and Bair had. Randy and John had climbed to the old claim and found an old pick and shovel there in the tunnel, probably left by Roy Harris.

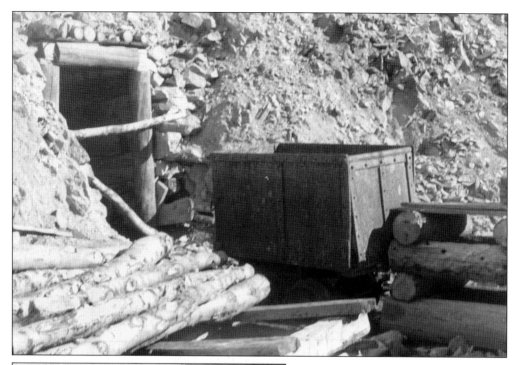

Every time the Allison Tunnel is mentioned, I am reminded that I was always cautioned to never go in it beyond 200 feet, since in that area I was told that there was poisonous gas. With this barricade in front of the entrance I was not likely to invade its sacred depths. I was told (I do not know how truthfully) that the Keoughs considered drilling down from atop the tunnel to let fresh air into it at that distance. I'm sure that was never done.

On September 17, 1963, when I was taking a breather from picture taking at the #1 drill site of American Climax, I had thought I would go to the St. Julien. I went up the East Fork as far as this old bit of framework. I later learned this had been the start of the Ethel Mae, the plant at Edwards Gulch where the Cayuse Kid had hauled 100,000 feet of lumber in 1905 and then gone and hauled it down again. It was a good thing I started back to the #1 site, for I just caught the helicopter's last trip down. I'd have been afoot for a 7-mile hike out.

This is where my son Duane worked one winter. It was quite possible to get a trailer house into areas where the fellows wanted to live and work. Some winters the snow cover in the Gulch was rather light.

The Counts name has been associated with Emigrant gold since 1874. Here Garland Counts stands atop the divide between the east fork of Emigrant and Arrastra Creeks, which drain into Mill Creek. He told us he was considering the possibility of building a road down into the east fork to the old McAdow, which were on Birdie Ridge across from the St. Julien. The bright streak on the third peak of Emigrant Mountain shows from here. The #2 drill site of American Climax was at its foot in 1963.

83

I went to the top of the divide between the east fork and Mill Creek with Garland in 1974. The next year he took Bill and me up. From where we left the road on the west fork of Mill Creek to the divide there were 36 switchbacks in the road. The first three of them led to the road that took off to Kester Counts' Barbara Ann Claim. Kester and Garland were brothers.

This is the truck in which Garland Counts negotiated the many switchbacks in the road, often having to back up and take several turns. He had built the road with his Cat, and when it broke down and required a mechanic's service, he got Jim Stands (Randy's dad) to go repair it. Jim then drove it down the switchbacks.

Bobbi and I had gone up to the drill site where Rich Statler and Jim Peterson worked on July 14, 1972. That is the day we cut across to the St. Julien. I don't think that she has yet forgiven me for dragging her through all of that underbrush. But, we still have it to laugh about. In this photo you can see the boxes of core on the truck bed.

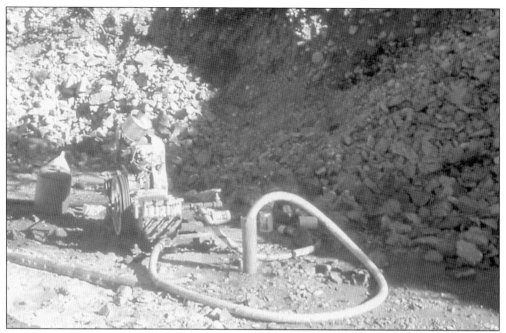

Somewhere in my early reading about Emigrant Gulch, I remember a statement about there being many underground channels of water. I know this to be true for the artesian channel hit at the #2 drill site far up on the peak in 1963. Many of the drill holes have had to be capped when abandoned. This one would obviously have produced a muddy road if the water had not been cleaned and returned to the creek.

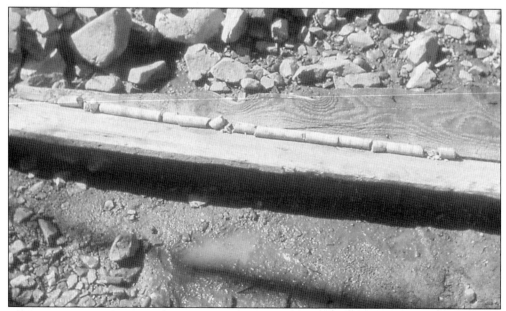

This is a sampling of core that has been drilled. It is quite small in diameter. At the #1 drill site in 1963, the core was 3.5 inches in diameter to 589 feet deep. From 589 feet to 1,505 feet they drilled a core that was 2.4 inches in diameter. The core shown here is probably less than an inch in diameter.

Seven

THE ST. JULIEN

I lost my soul and my sole to the St. Julien on October 3, 1963. After being within 200 yards of it on September 17 and deciding that there could be nothing more interesting for me to find, I had returned to the #1 drill site to fly out with the last copter load.

I had then gone home and talked to George Larson who had been in the upper parts of the East Fork in 1913. He offered to go with me to locate the St. Julien. He was 70. It would mean a 7-mile hike from the end of the road, but we were both good walkers.

We made an early morning start with a lunch. I wore the old hiking boots that I had left over from rural Nebraska school-teaching days, resoled by this time. Needless to say they were ready to lose a sole, which they did, and as a consequence, I hunted a soft rock all the way back to the car.

With my first view of the St. Julien, I lost my soul to it. There it was standing among the trees, idle as it had been for 57 years, little disturbed by human habitation. Because there was so little above it on the East Fork, there had been little traffic on the trail except for those who wanted to view the memories it held.

George and I reached the site about noon. It was a beautiful October day in the quiet of the mountains. It was a place to lose one's soul—a place to become engrossed in the dreams that hardy mountain miners had dreamed the many years before.

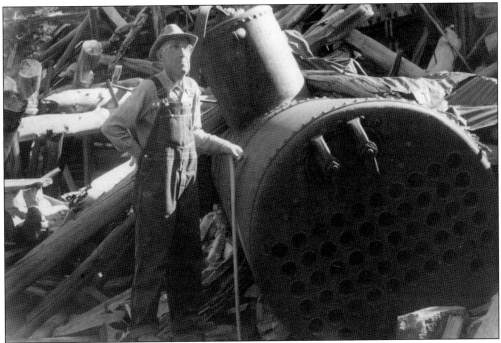

George Larson stands before the ruins of the St. Julien Mill on October 3, 1963. Here it had stood unused since closing in 1906. The boiler had slipped from its moorings above.

George snapped my picture as I sat finishing my sandwich on what had been the roof of the boiler house.

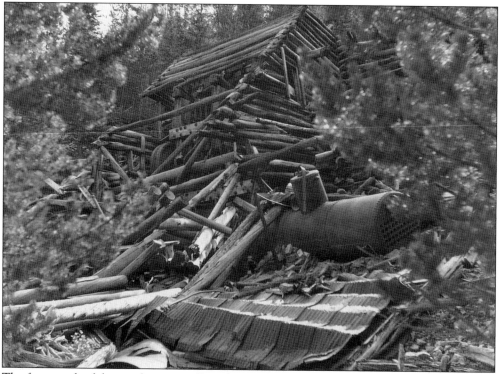

The framework of the window was still in place under the pole roof on the main part of the St. Julien Mill.

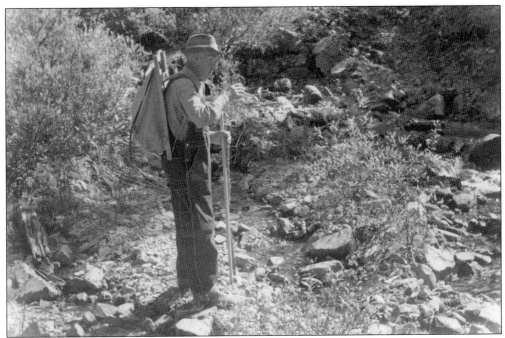

George Larson always traveled with a walking stick, and for the convenience of both of us, he carried a back pack.

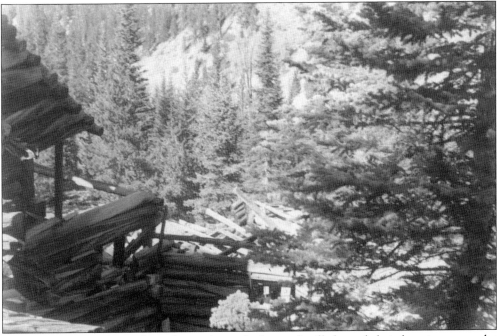

Two of the large cabins where the workmen had stayed still showed their locations near the mill. Among the things we found near these were old milk cans and evidence of the food used.

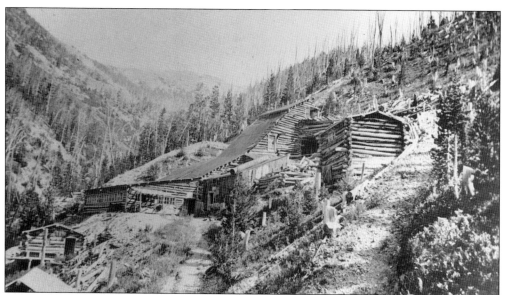

My best view of the wonderful St. Julien Mill came several years later. Bud Briggs told me he had a lot of pictures and asked if I would care to see them. Sure, I would! I swear I looked at 200 uncles, aunts, and cousins, and then there it was—a postcard of the St. Julien probably taken about 1912, for the stovepipe was already down. The little assay house was down on the creek bank and the housing for the rolling tables was still intact.

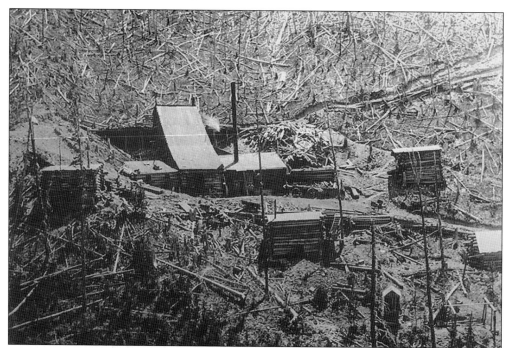

Later many views of the St. Julien in its operating days came into my hands. Bill was always glad to reproduce them. This one came from E.J. Wemlinger of Wheatridge, Colorado, who long had financial interests in the St. Julien. This was taken in 1901 before the big mill was built in 1904. Note the horse-drawn wagon on the road above.

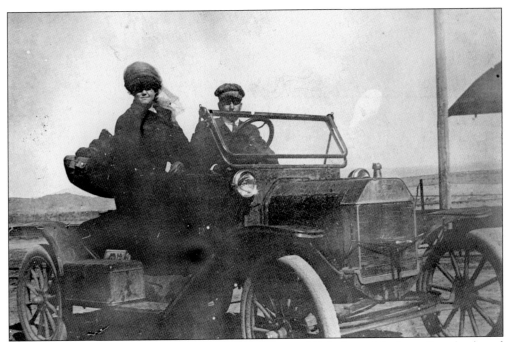

Here are Mark and Lizzie (Fodness) Edick in their car in 1914. Cars with these slim wheels and tires could make it all the way to the St. Julien. When there was difficulty with a steep grade sometimes, the car was backed up the grade.

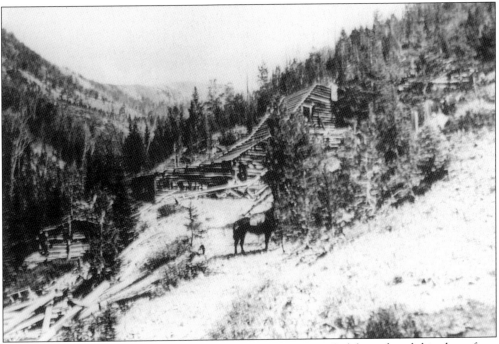

Bill Amsk, who was long interested in the mining in Emigrant Gulch produced this photo from the 1930s. Notice that the log roof of the mill has become completely exposed. The two big buildings to the right that were abodes of the miners have ceased to be.

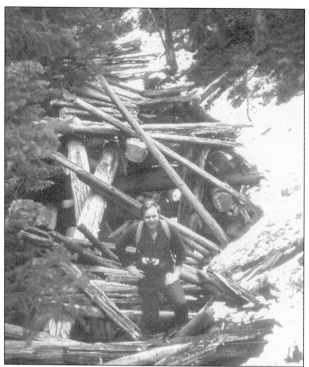

In 1970 I went up to the St. Julien with John Carson of Paxton, Illinois, shown here under a bridge just above the St. Julien. Carson had claims for Golden None Such and made six trips out to them. He hired Don Reichmuth of MSU, who later founded the GeoMac Co. for doing representation work to do his.

When John Carson visited the St. Julien, it looked like this. His traveling companion that year was Kenny Nordin. He had claims above the Great Eastern and below the bright streak on the third peak. He found some silver in claims across from Mineral Mountain but thought it too expensive to get out and process. He sold his claims to Montana Mining and Reclamation in 1996.

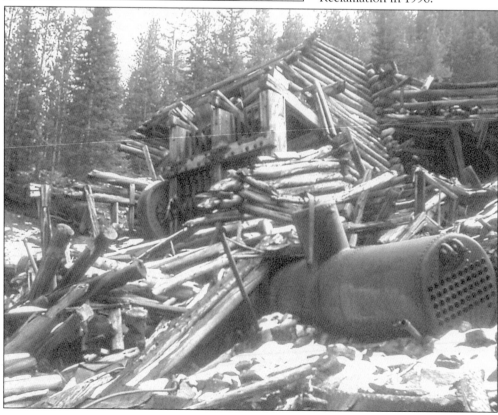

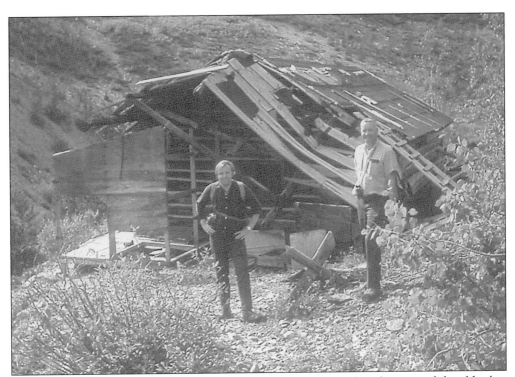

Johnnie Carson and Kenny Nordin stopped at the forks of the creek and examined the old cabin there. It was showing signs of age in 1970. The shower stall was gone, and the roof had lost its protective defense against the weather.

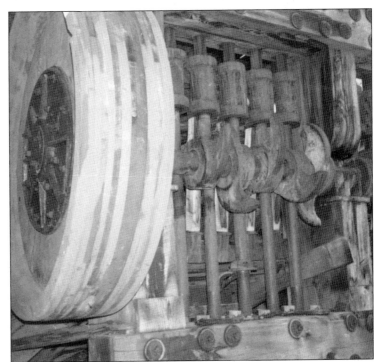

In 1972 I sent Wemlinger some pictures with a suggestion that we should bring out the parts and reassemble them on the hillside at The Wan-I-Gan, which we still owned at that time. The big wheel with a heavy belt operated the rolling tables and the stamps.

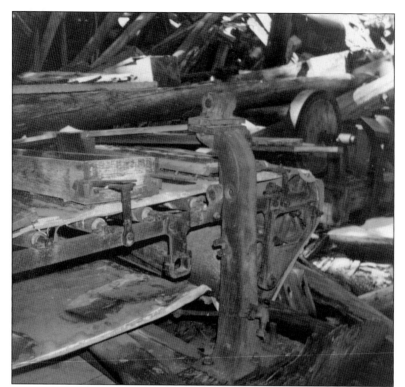

The two roll-ing tables were still intact. New canvas for them would make them operable.

The ten stamps that had been the crushing power of the mill were still in good shape.

It so happened that when we were living at the Park County Museum, the Kent Shorthills of Vancouver and John Carson of Paxton, Illinois, happened to be in Livingston at the same time. Each of them made contact with me, and we got together for an evening of pictures of Emigrant Gulch via slides I had taken. I have made those into a video by projecting them on the screen and talking with them while I run the video camera.

The young son of the John Vinings climbed into the debris of the St. Julien in 1980—his small feet are a contrast to the heavy walls of the bin into which the ore was dumped to be taken to the stamps. All of these components of the defunct mill show evidence of the pride that went into its construction 76 years before.

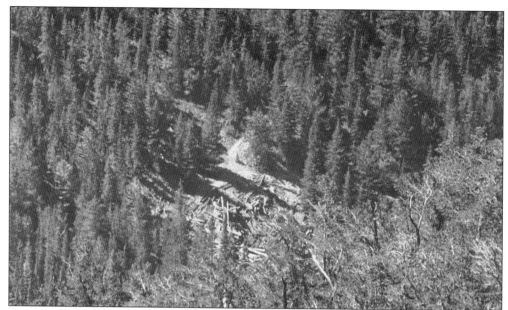

In 1975 when we accompanied Garland Counts to the Mill Creek divide at the top of Arrastra Creek, Bill took this telephoto of the remains of the St. Julien Mill from that distance.

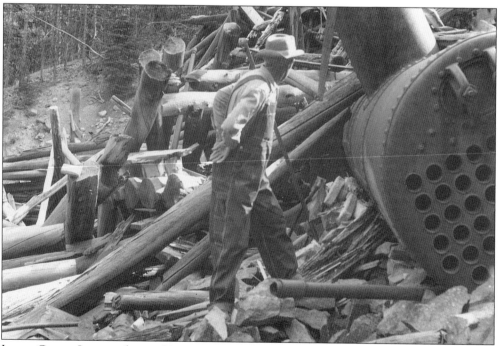

It was George Larson who, at 70, gave me my first sight of the St Julien. I shall never forget that October 3, 1963 day when we walked the seven miles from the end of the road to the old mill. It was George who told me about his memories along the route and the people he had remembered—Allison, Cameron, Fodness, Roy Harris. George went to Chico, White City, the dredge pond, and the cemetery with me. But he never got back to the St. Julien with me. God bless him for that first trip I had with him.

By 1975 my husband had become interested enough in the Gulch that he went up with some of the drillers who lived in Wan-I-Gan cabins and got some very good shots of their work.

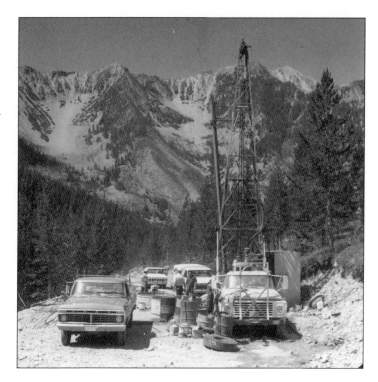

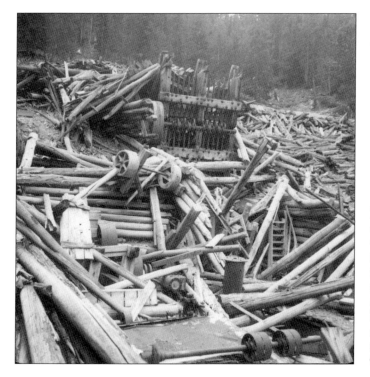

Bill went on up above where the drillers were working and made some interesting shots around the old mill. This shows the stamps still standing erect, a thing that could have been taken out for repair and display either at Wan-I-Gan or Park County Museum.

97

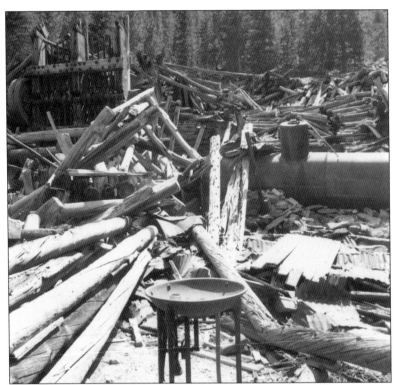

I have wondered about the pan where the heating of ore must have been done. This vessel has not shown up in any other pictures taken around the mill. Was there more iron pyrite there to test?

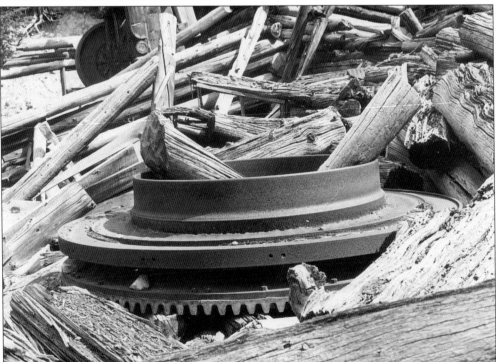

Bill's pictures show how much of the wood has rotted by the exposure it has had to the elements. Many winter snows have melted into it. The heavy metal pieces have survived very well.

In 1934, E.J. Wemlinger, who still had a large interest in the St. Julien, had this survey of the claims in the Emigrant Mining District made. He was thinking of opening up mining in the area. This shows T.7 S., R.9 E. in March 1934 on a scale of 1 inch–300 feet. Note that the spelling of the mine is with either an "a" or an "e". Nothing seems to have developed from these plans that were told of in the Livingston newspapers.

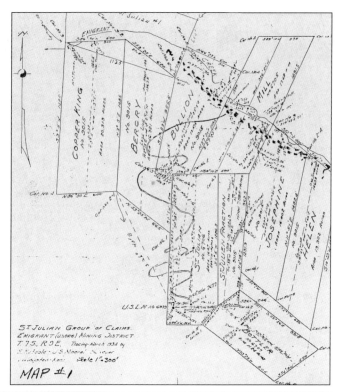

As I was working on the chapter about the St. Julien, I had a visit from a fellow history lover, Ellery Christian. He mentioned that he had some pictures he took the day he had gone with Bobbi Sackett, Webb and Phyllis Sullivan, and me up the Gulch. I had taken videos that day. For this book I have gleaned pictures from Ellery's collection. The big boulder attracted his attention as it does those who pass on foot or in vehicle. These pictures were taken July 26, 1992.

Here is Bobbi Sackett quenching her thirst as Phyllis Sullivan looks on. The water on the East Fork was clear. None of us had any qualms about drinking it.

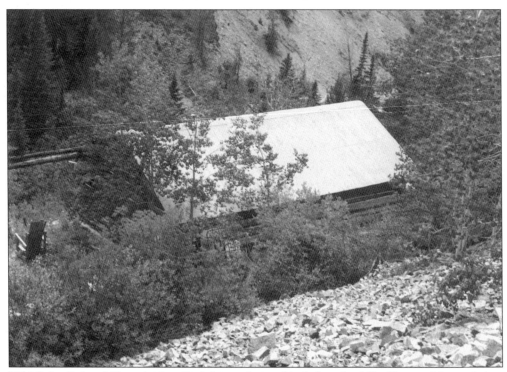

Niki (Mrs. Robert) Keough identified this as their cabin below the falls. She would spend time there when Robert was pursuing his mining interests in the area.

I have no good pictures of the high falls
in the main creek above where the East
Fork takes off. On the left side of this
canyon Bill and Elvin Clayton had their
claims. The mining Clayton's neph-
ews have their cabin in Chico. David
Clayton of Billings and Frank Clayton of
Livingston use the attractive little place.

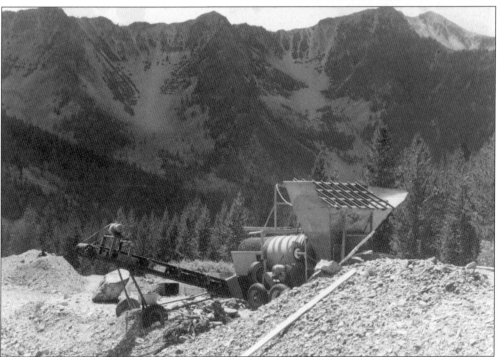

Ellery had a good picture of this concentrator on the East Fork that the environmentalists had
examined two years before.

Back in the woods, Ellery spied the cabin that he thought was the old assay house when the St. Julien was operating. George Larson had found papers in it in 1913 that dated back to 1906, when the St. Julien closed. Bobbi, Phyllis, and I were amidst the rubble.

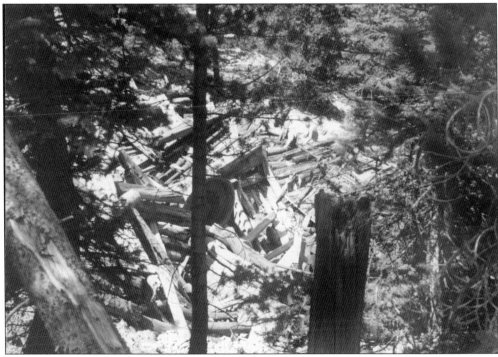

This was originally a two-story building that the employees had used as their dwelling. There were once two buildings like this.

Bobbi Sackett stands near the entrance to where miners were working at this time. It was on a road they had built beyond the St. Julien Mill site.

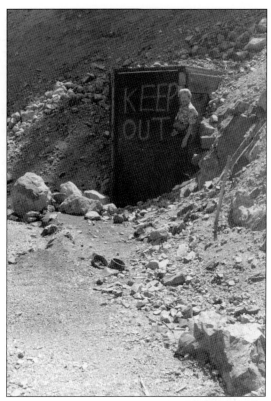

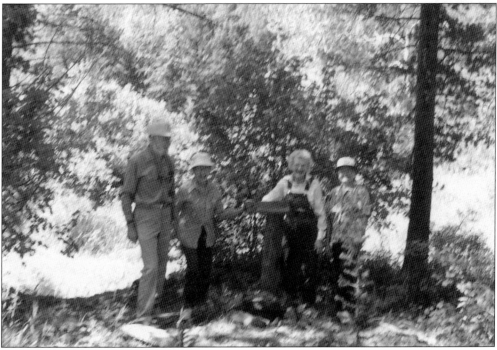

The pulpit of the Chapel in the Pines was still standing when we were there in 1992. Pictured from left to right are Webb and Phyllis Sullivan, Doris Whithorn, and Bobbi Sackett.

A small part of the old garage wall was still in evidence in White City. It was below Balm of Gilead Creek. The White City cabins were across the creek.

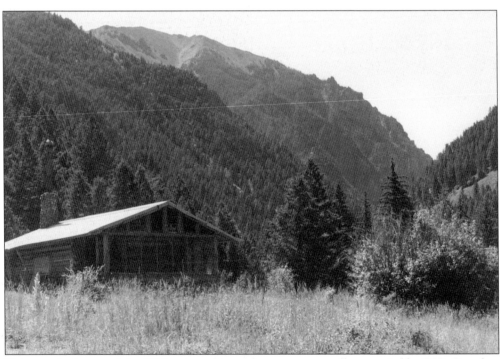

This was the largest of the White city cabins—that one was usually occupied by W.F. Carr during his time with the Hy-Grade Miners.

This is one of the buildings left from White City. Phyllis Sullivan seems to be going down to examine it. Emigrant Creek is just behind and down the bank from it. This over-grown patch of vegetation has served as the picnic area for many people in times past. The first Chico School picnic that we Whithorns attended was held here in May 1949.

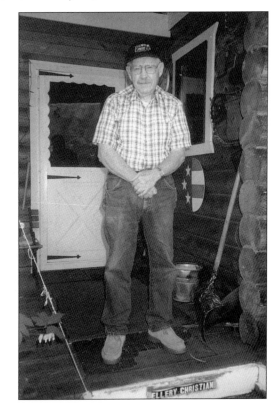

Ellery Christian came from Wisconsin to Montana to help Jack Jr. and Martin Davis by being the cook at their hunting camp in Stands Basin. When he retired from that he pursued history, jewelry making, gardening, and other crafts. Here he is at his home near Pine Creek. Thanks for your pictures, Ellery.

When Bobbi Sackett and I had ridden up to Rich Statler's drill site in 1972 and then cut across through the timber to the St. Julien, she filled some empty beer cans with iron pyrite (fools' gold) as our souvenirs of the day.

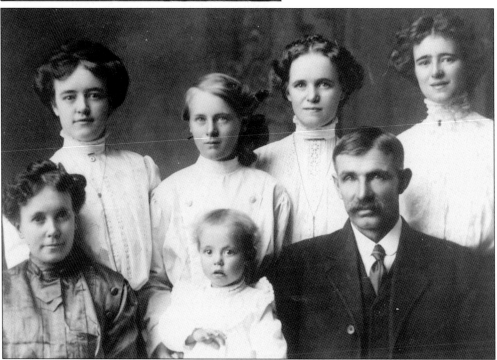

This picture of the Jack Fodness family was taken September 26, 1910. Pictured, left to right: (front) Mother Agnes, Edith, and Father Jack; (back) Lizzy, Berniece, Ella, and Aggie. All of the girls married men who worked in the area: Edith (Don Blakeslee), Berniece (Henry Billman), Ella (Ross Williams), Lizzie (Mark Edick), and Aggie (Keough and Putzker).

Ralph Leatherman, pictured at the tunnel entrance in Chico, is expressing a work ethic of the 1930s when he and his father and Frank Hill did some mining. His father was Alvin W. Leatherman, a justice of the peace in Gardiner in 1904. He was also the road boss when the road was built over Dunraven Pass in 1903.

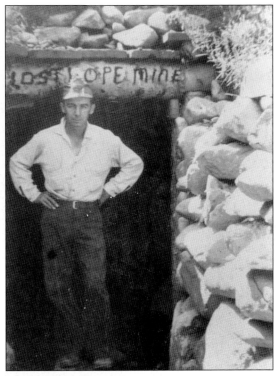

Benna Busby worked for me for 17 years at the Wan-I-Gan. Her presence gave me lots of freedom to get away from store duties. I always enjoyed my trips up the Gulch. It even gave me a smattering of information for which I was paid with a 1 percent interest in the ownership of 12 claims on July 31, 1968. In December 1975 this came to me in a $300 check. What a surprise!

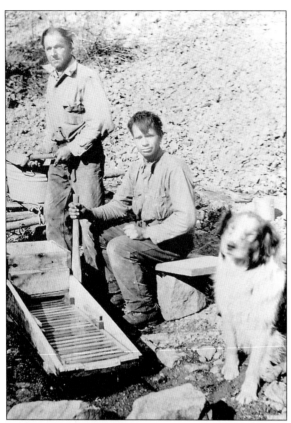

There is no question about it: I am sometimes confused by the terms miners use and their meanings. A trommel, Webster says, is a screen used for sizing rock or ore. A concentrator is the noun of the verb telling of gathering into one body something like ore. From the environmentalists' visit on August 11, 1990, I have these listed as trommel, washer, and concentrator. Give me something simple like this rocker, where Harris and Frank Looke are shaking gravel to let the gold settle in the riffles. We have one of these at the Yellowstone Gateway Museum

Brothers Jack and Bert Anderson greeted Bobbi Sackett at their area of work near the oil tanker bridge in the creek. The Andersons' had been raised in Chico and attended school there after their folks moved to Montana from Missouri. They worked on their claim for about 30 years.

Eight

AFTER 1980

There is no mining in Emigrant Gulch at this time, summer 2002. There are two residents who have lived in Chico for over 60 years.

Neither were miners. Albert McLeod has trouble with his voice, and his left leg makes walking difficult since his light stroke a few years ago. Ruth Conlin walks her dogs every day and feeds her horse, but she has difficulty hearing or seeing. There are some more recent residents.

The schoolhouse is the extra storeroom of several residents. The shelves in the hall house many books, it is said. There is no core stored there, as was once the case.

I remember a time when Louis Counts showed me a little bottle of gold he had panned out of the creek in Chico. I wonder about its value and where it is now. There were no nuggets of any size in it.

I was told that during the depression of the 1930s miners could get enough placer gold to make a fair living. I wonder if that could still be so. Roy Harris always told me he could never pan out any gold above the St. Julien. Is the Mother Lode still there somewhere? These years after 1980 there have been companies looking for it above the St. Julien.

To go into big operations costs so many millions that only large companies have considered Emigrant Gulch. To patent a claim, to work it, or to have the representation work done on it —that is a far-fetched dream for the little miner. So, Emigrant Gulch remains among those who moil for gold, there is he who dreams and he who leaves.

Pictured are visitors at the St. Julien ruins on August 22, 1980: Mr. and Mrs. John Vining and two children, and Sheri Peters in front; in the back are Randy Stands and Mrs. and Mr. Wheeler (Mrs. Vinings' parents). Bobbi Sackett is off the the side looking for rocks.

Tom Jerde, who with his wife Sherral, followed Bill and me as resident directors of the Park County Museum in 1986, visited the site of the St. Julien to see what was left. We looked over the papers and letters I had received in answer to my correspondence about acquiring its parts for reassembly at the Museum. To him I think it looked like an impossible dream, but I had faith in his construction ability.

On July 11, 1989, Kent Shorthill started his video camera as he left Livingston and recorded history en route up the valley. He stopped at the Shorthill Cemetery and in Chico before getting to the St. Julien area. Bill Ogg (left), who had recently come to the Gulch as an employee of Montana Mining and Reclamation, was with us at the time.

110

On July 11, 1989, I sat with the Shorthills among the ruins of the old St. Julien Mill. Next to me was Kent's mother, his wife Pat, Kent, and their children Berkeley and Meleea. When I visited Bobbi Sackett's winter home in Camas, Washington in 1993, the Shorthills of Vancouver entertained us. We spent an evening reliving Emigrant Gulch days. That was always fun.

The October 9, 1990 *Enterprise* told how Bill Ogg's operation would employ a helicopter to haul supplies to their drill sites. When I heard that the pilot was to be Harold Skaar, I was delighted. I had known him since the early 1940s when, as a child, he played with my children several times a week as his mother and his sibling visited with me and my children. Here on April 11, 1945, were my son Bruce, Bonnie and Harold Skaar, and Carol Whithorn.

Eve Art of Chico Hot Springs rode in the front seat with Pilot Skaar. Bobbi and I rode in the back seat. Conversation was easy since the chopper was not a bit noisy.

As a pilot, Harold Skaar had installed the microwave tower on Highlight Peak at the top of Tom Miner Basin.

Nancy Ogg, Bill's wife, stood in the doorway of her cabin home in Chico as we took off in the helicopter. It was the house that the Kester Counts family had lived in during the years of my children's school days in Chico.

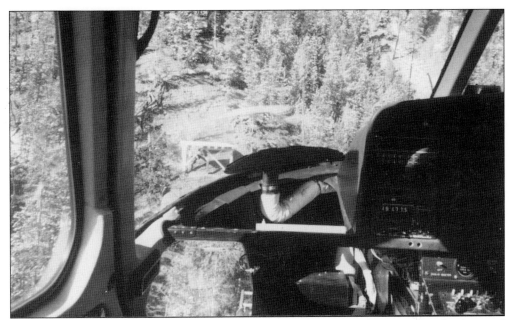

Here we were approaching one of the landing pads on the East Fork. Soon after the first trial flights, it was decided to make 15 pads along the hillside rather than try to move them. They were quick and economical to build and proved less trouble than moving them involved.

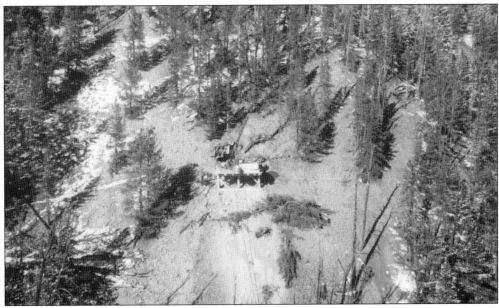

By using the helicopter to haul in supplies, Bill Ogg said, they would avoid having to construct a 10-foot wide road on some steep slopes. Wooden drill platforms would be built for a copter pad at the drill site with a neighboring pad to accommodate the drill. A series of 15 landing pads were to be built.

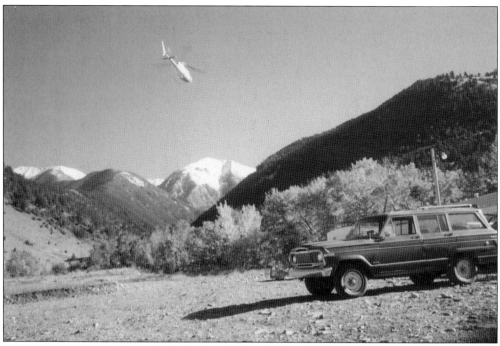

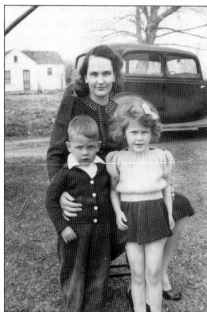

There was a good landing field at Chico, just down from the school house. It was the same one the helicopter had brought out material from the 1963 drill sites that Boyles Brothers had up the Gulch in 1963.

In May 2002 I had occasion to visit Harold Skaar's mother in Sheridan, Wyoming, for an hour. She said that Harold is still piloting helicopters and likes the work as much as any he has ever done. He lives in Spokane, Washington. This was his mother with him and his sister Bonnie in 1945.

On August 11, 1990, Bill Ogg's Montana Mining and Reclamation Company was visited for an on-site inspection by John Griffin, Montana Mining Reclamation official. Anyone present at the inspection had to sign in. The list included David Scrim of the Park County Environmental Coalition, and Jeanne Marie Souvigney, GYC of Bozeman.

August 11, 1990, I left home at 7 a.m. to go with Bill Ogg and the reporters and environmentalists to his RVC drill site. Bobbi Sackett and I rode up with Bill Ogg. There were five other carloads of people going. We all got an explanation of what Bill's company was doing and how he was obeying all regulations. He was even spraying knapweed, he said. Everyone looked over the trommel and washer at Edwards Gulch. Everyone was back down by 2 p.m. The *Enterprise* carried a report on the day's activities.

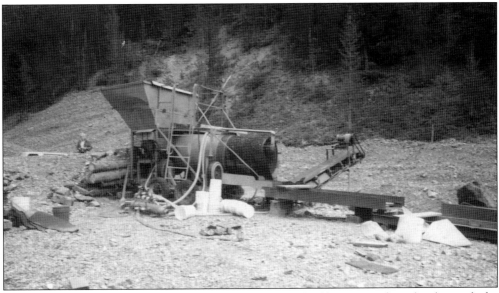

Many who looked at the trommel and washing operation had been entirely unfamiliar with the work carried on. Eve Art of Chico Hot Springs, Matt Gibson from the *Enterprise*, Park County Commissioner Carlo Cieri, Sandy NyKerk, and Lill Eflickson from the Bear Creek Council/ GYC, and Valone Drake of the Greater Yellowstone Coalition were there.

PEGASUS GOLD INC.

In April 1992, Pegasus announced plans to continue exploration of Emigrant Gulch, trying to determine how much gold lies beneath the rugged mountains there. Thomason said that the company still did not have enough information to know whether to try to develop a mine in the area. He said that even open pit mining might be done.

EMIGRANT

The Emigrant property is located about 30 miles south of the town of Livingston in south-central Montana. Pegasus has the right to earn a 77 percent interest in the property by taking the project through to feasibility. Fisher-Watt Gold Company would hold the balance of 23 percent.

The property is underlain by a series of altered volcanic rocks that host a number of zones containing gold or gold-copper mineralization usually associated with major structural features. The property consists of 7,900 acres and has the potential to host several bulk tonnage deposits. The limited amount of drilling and surface exploration work done so far has been very encouraging. Emigrant is a high priority project and $1.2 million has been allocated for land payments, geologic mapping, geophysics, sampling and additional drilling.

Of this property in Emigrant Gulch Pegasus said in its annual report that the property consisted of 7,900 acres and had the potential to host several bulk tonnage deposits. It said Emigrant was a high priority project and that $1.2 million had been allocated—for land payments, mapping, and drilling.

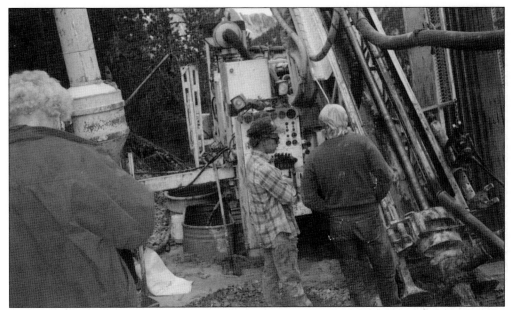

Pegasus Gold Inc. came to work in Emigrant Gulch in 1991. The report from them said that the limited amount of drilling and surface exploration done so far was very encouraging. This was the drill being used on a road to the right and above the old St. Julien mill.

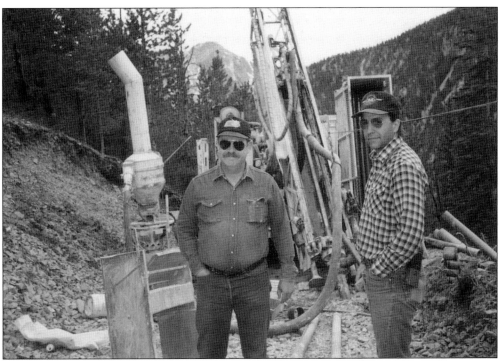

Bill Ogg and geologist Mike Malowski stand in front of the drill which had drilled nine holes to a depth of 285 feet. They had planned to drill a total of 45 holes, 10 of them in this particular area above the old St. Julien Mill. On July 29, they were thinking that they would let the tenth one go.

Bill Ogg said it would take five years to drill test holes in Emigrant Gulch because there was too much snow. In Nevada it could have been done in two years. There is a lot of paper work to go along with the drilling. The hole drilled here was #4124B. This machine was taken out on July 29, 1991. Plans were to move it to Cooke City, Montanta.

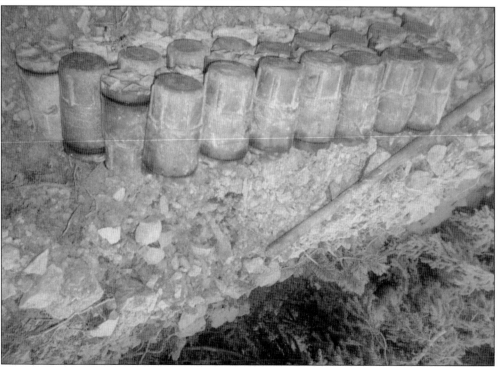

Here are containers that Pegasus takes out of ground up material. It reminds one of rice. Each canister is marked for the depth from which it comes. Pegasus is big in Montana. The main of-fice is in Spokane, but the company also has offices in Butte, Montana, and Sparks, Nevada.

118

This is the machinery used by Pegasus on the road to the right of the St. Julien Mill. Water was not allowed to go into the creek. Pegasus drills its own holes, as one driller does not believe another driller. They have to find out for themselves.

When the road was built to the right above the St. Julien, a water pipe that had served the St. Julien Mill was cut into. Bill Ogg said they have never found the tunnel that they were taking ore out of for the St. Julien. Bobbi and I climbed 13 switchbacks to the top of the hill and found they had dug down from there. The hole was securely fenced. We found a bit of track and an orecar en route.

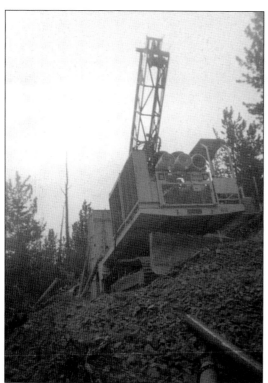

This is the big drill coming down the mountain from the road that had been built beyond the St. Julien. The date was June 30, 1991. The drill weighed 66,000 pounds. Bits were ten feet long. Plugs were put on the drills to protect the threads on them.

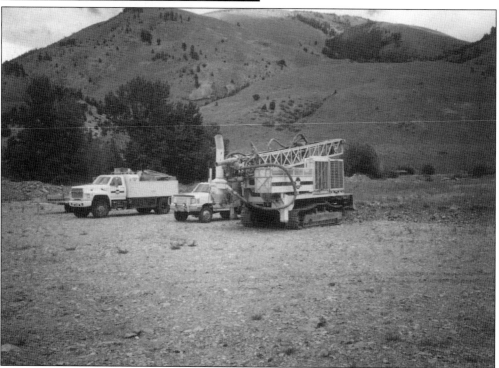

The drill came to the parking lot in Chico. It took five and a half hours to bring it down from above the St. Julien where it had drilled nine 400-foot (or so) holes.

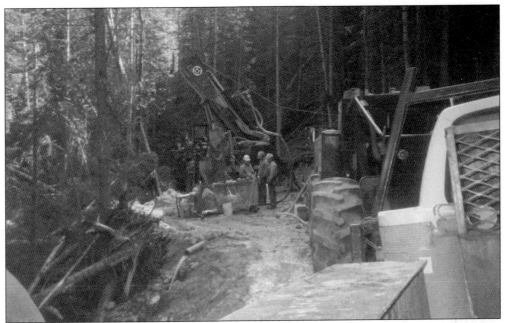
On September 11, 1992, two different kinds of drilling were planned—one above and one below the St. Julien site. This was the RVC (reverse circulation) drill which worked at the end of the road built the previous year.

Bill Ogg introduced us to Joan Gambelman, the geologist. He said we were the only women who came to their work area besides their female geologist for whom he had much admiration.

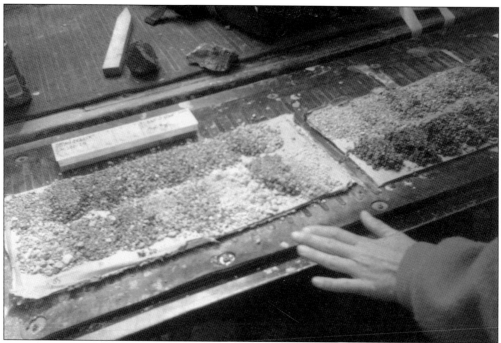

Here geologist Joan Gambelman is shown examining samples of the ore drilled from 420 feet down under the RVC drill.

Bill Ogg took Bobbi Sackett and her houseguest, Clare Lee, and me to the RSV drill site in his truck. Mr. Lee was not interested in going with us that day, so Bill had strictly female company.

I got up and made potato salad that morning; others brought the makings for a tailgate lunch that beautiful September day in 1992. Riding up the gulch in Bill's truck was so much easier than some of the earlier trips we had hoofed it in on.

An artesian well continued to flow alongside the road near the RVC drilling site. For the video I was taking that day, Bill Ogg turned up the faucet and it really put out a head of water. But I did not get a still shot of that; so I'll just show our group Bobbi, Bill, Doris, and Clare.

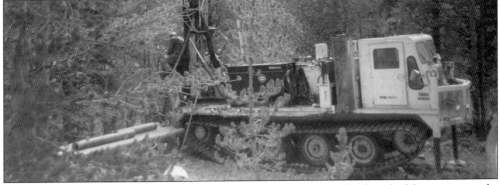

This sonic drill was brought directly from New York City, where it had worked for seven months in the sewer tunnels beneath the streets. It came to Emigrant Gulch to drill below the St. Julien site and a short distance below Edwards Gulch. It was mounted on a chain track.

123

It was September 11, 1992, when this much heralded sonic drill arrived in Emigrant Gulch from its seven-month job in New York City. Here is where it hit the rock that it could not penetrate. The workmen who came with it moved it out of Emigrant Gulch. We were told that it was to go to Cooke City for a job.

Bobbi's and my last time to go up the Gulch was September 17, 1997. We rode up with Bill Ogg to the place below Edward's Gulch where he had had a trommel in 1991. Bill was doing the work for Brown Minerals of Waco, Texas, in 1997. Jim Bailey was the driller with Bill and Bobbi.

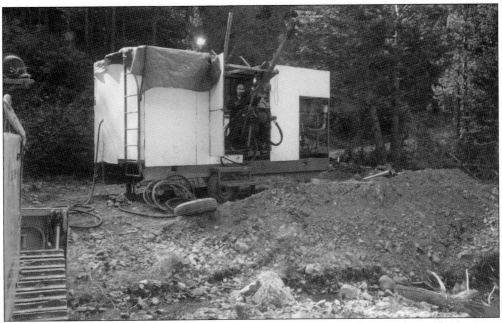

This is what the boys called the drill shack. The driller's helper, Mike Shirrah, was looking out the doorway. He was the son of the current owner of The Wan-I-Gan, which our family had called home from 1948–1976.

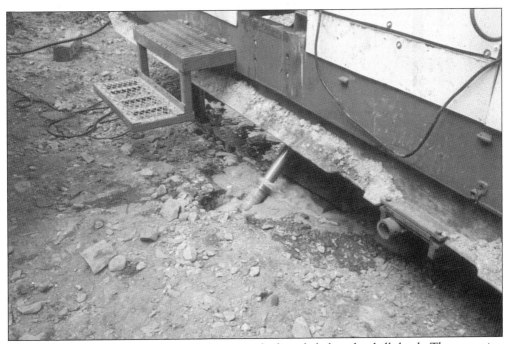

The drill goes into the ground at a 45 degree angle directly below the drill shack. The operating machinery is inside the shack. This is one of 11 holes they drilled at that location.

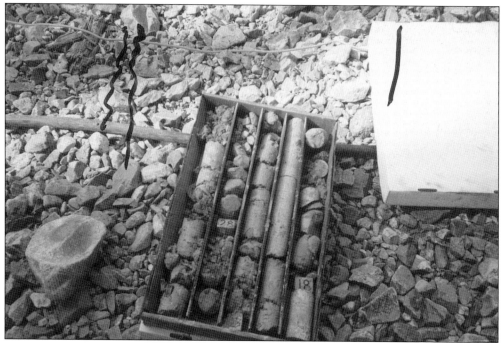

Brown Minerals was interested in having core taken from the drill holes. It was stored in boxes like this. These were the same kind of core boxes that we had stored at The Wan-I-Gan in Cabin 6 for Noble Resources of Reno, Nevada and their successors for three years starting February 1, 1973.

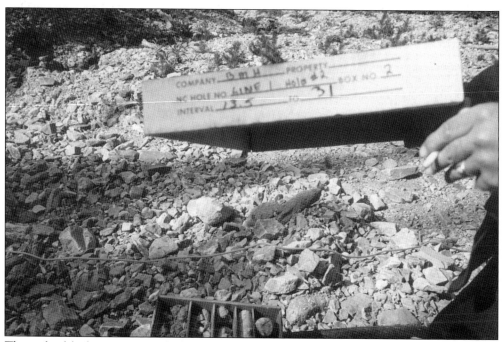

The ends of the boxes were marked with the company name, the location of the drilling, and the interval. This was the common way to preserve the information necessary for the company.

This shows the device that Jim Bailey used to clean the water before it was let go back into the East Fork of Emigrant Creek.

This was a location where Jim Dailey expected to drill for Brown Minerals when he moved from the place where we saw him and Mike working. All were in the flat below Edwards Gulch where a hiker would turn sharply to the right to go to the location of the old St. Julien. It was the place where I had turned around and gone back to catch a copter ride out on September 17, 1963.

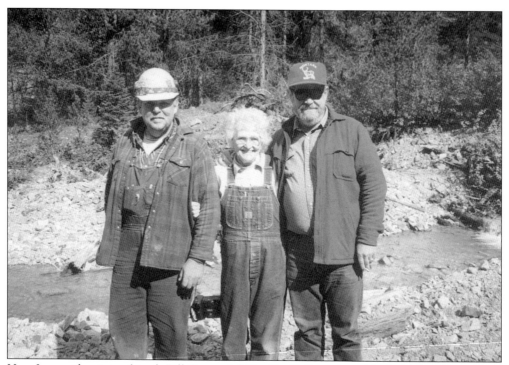

Here I am with mining friends Bill Ogg and driller Jim Bailey, whom I had also known since his youth. I'll be forever grateful for the time and trouble my Emigrant Gulch friends took to tell me of the dreams of mining wealth. Asked how many companies Bill worked for in the Gulch besides Montana Mining and Reclamation, he replied Kennicut, Pegasus, and Brown. Now he has his own business near his Missoula home where he makes and sells mulch.

Of the 12 girl graduates of Shickley Nebraska High School in 1934, two of us married men who acquired Hasselblad cameras in the 1960s. It was the one the astronauts took to the moon. Betty and I enjoyed this cartoon.

128